THE A. B. FROST BOOK

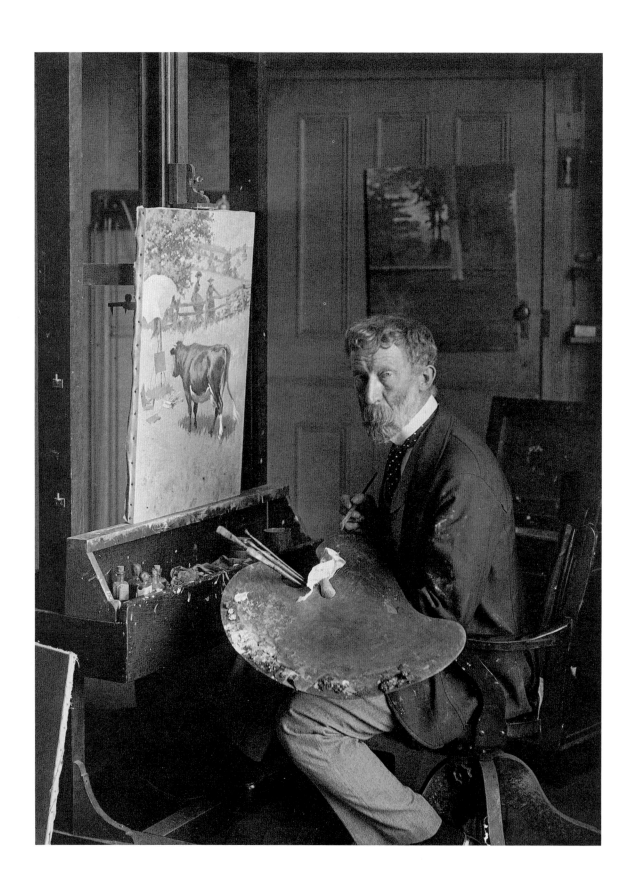

THE

HENRY M. REED

A. B. FROST

WYRICK & COMPANY

BOOK

Published by Wyrick & Company
Post Office Box 89
Charleston, SC 29402

Edited by Roberta Kefalos
Designed by Sandra Strother Hudson
Printed and bound in Hong Kong.

Library of Congress Cataloging-in-Publication Data
Reed, Henry M.
The A. B. Frost book / Henry M. Reed
p. cm.
Includes index.
ISBN 0-941711-13-7 : $49.95
1. Frost, A. B. (Arthur Burdett), 1851–1928.
2. Artists—United States—Biography.
I. Title. II. Title: AB Frost book.
N6537.F789R44 1992
760'.092—dc20
[B] 91-32995
CIP

Portions of this book were originally published in
The A. B. Frost Book, by Henry M. Reed
Rutland, Vermont: Charles E. Tuttle, 1967
and are used here, either in the original version
or in a revised version
with the permission of the publisher.

Frontispiece: A. B. Frost at his easel, c. 1900.

Contents

CONTENTS

Foreword

*A*rthur Burdett Frost stands among the first rank of American illustrators, excelling in a range of styles including realism, humor, and fantasy. His illustrations exhibit a complete understanding of both the letter and spirit of the authors to whose writings his drawings gave pictorial life.

Frost was particularly successful in depicting small town and country characters and situations. His presentation of moments in the life of the American middle class was usually done with a smile, and frequently with a broad grin. It is to be noted that he is not associated with authors of the romantic fiction that enjoyed a wide popularity for a decade or two at the turn of the century.

Mr. Frost was famous for his hunting and fishing scenes. Even if one is not a sportsman, they must be admired for the beauty of their backgrounds of forest, stream, and marsh. His love of nature vied with the fascination of rod and gun.

For pure humor one may be recommended to the series of comic sketches, as in the little volume *The Bull Calf*. But his masterpiece is the hilarious tale of *Carlo*, a work that every dog lover must admit is also a realistic presentation of the canine character.

It is this writer's considered judgment that A. B. Frost arrived at the height of his powers in his illustrations of Joel Chandler Harris's tales of Uncle Remus. What gives them life is the subtle mingling of realism, humor, and fantasy that no other artist who has taken the black storyteller to his drawing board has been able to attain. For an example, study the scene of Uncle Remus meeting Brer Rabbit and observe how skillfully the three stylistic elements are intermingled.

In 1886, the editors of *Century* magazine suggested that Frost travel to the Deep South in search of local color for illustration of stories by Harris. The two met and

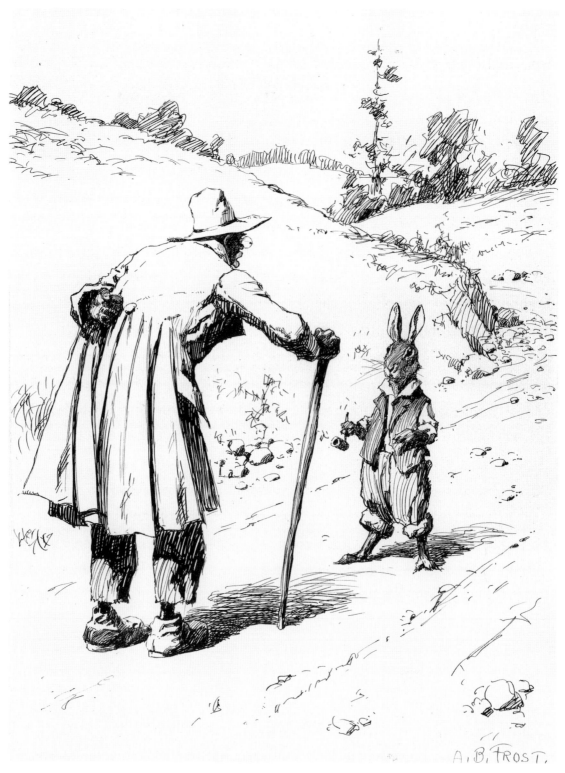

Uncle Remus Meeting Brer Rabbit on the Big Road, pen and ink. Private Collection.
Frontispiece for Joel Chandler Harris's *Uncle Remus Returns*, 1918.

spent several days together to the north of Atlanta. Frost expressed himself as somewhat disappointed with his findings, and his sketchbook shows little that he was to use. But his eyes had done what his pencil failed to do. Returning to the North, his memory carried minute details of the Georgia scene that were to make Brer Rabbit and the other "creeters" inhabitants of a world as real as any that could have been shown in photographs. While no critic has failed to note the lifelikeness of the animal characters, their environment has been generally overlooked, and it is important.

When in 1892, Mr. Harris received pencil sketches and proofs of illustrations for *Uncle Remus and His Friends*, he was amazed and delighted. And in the preface and dedication of the 1895 reprint of the *Songs and Sayings*, Harris gave wholehearted praise to his artist-collaborator.

Henry M. Reed has enjoyed a long and intimate connection with the Frost family. Greatly admiring A. B. Frost's works, he began early to collect both drawings and paintings. A long and profitable study of the artist's career led to the publication of *The A. B. Frost Book* in 1967. This is a revised edition, enlarged both in text and illustrations. A definitive biography, it should ensure that with the life of Frost's best works fully established, the life of the artist will not be overlooked.

THOMAS H. ENGLISH
Professor Emeritus of English
Emory University
Atlanta, GA

Preface

A biographer's research is never finished. During the past two decades, since the first publication of *The A. B. Frost Book*, valuable new information has been discovered about Frost's relationship with Thomas Eakins, one of America's greatest artists; with Lewis Carroll, the famous British author of *Alice's Adventures in Wonderland*, for whom Frost illustrated two books; and with Joel Chandler Harris, author of the *Uncle Remus* books, several of which were illustrated by Frost. A bound volume containing dozens of preliminary pencil sketches for Frost's most important body of illustrations, *Uncle Remus, His Songs and His Sayings*, published in 1895, has emerged, providing us with a rare glimpse into the mind of the artist.

Sporting art devotees will be pleased to learn that many previously unknown shooting subjects have been discovered, at least ten of which are shown in color on these pages, in addition to many of those which helped establish his reputation as "The Sportsman's Artist."

Although passing mention was made of Frost as a student of Eakins in *The A. B. Frost Book*, I began to realize not long after its publication that the Eakins-Frost connection was much more important than I had realized. A more thorough reading of the Frost family correspondence from this period revealed Eakins' name on numerous occasions. Had not Eakins painted *two* portraits of Frost? And when, in 1884, Eakins married Susan MacDowell, the newlyweds moved into Frost's recently vacated studio at 1330 Chestnut Street, Philadelphia.

A fresh overview of the life and times of A. B. Frost during his years as an Eakins student, as well as the years after, reveals an amazing affinity between the two. They

shared similar temperaments, subjects and techniques. The career of Mrs. A. B. Frost (Emily Louise Phillips, 1852–1929), also an Eakins student, further helps to illuminate this period.

Every member of the Frost family was an artist of accomplishment. A. B. Frost studied with Thomas C. Eakins and William M. Chase; Emily Frost had been an Eakins student; John Frost studied with Richard E. Miller and Guy Rose; and Arthur B. Frost, Jr. studied with Robert Henri, Henri Matisse, Robert Delaunay and Patrick Henry Bruce.

From the most privileged vantage point, the Frost family observed and participated in one of the most exciting and important periods in world art history. Indeed, the half-century witnessed by A. B. Frost and his highly talented family spans the period from Brer Rabbit to the birth of abstract art.

It is gratifying for me now to be able to revise and augment *The A. B. Frost Book* with some new discoveries and insights into the career of this distinguished American artist.

HENRY M. REED

Acknowledgments

*F*irst of all I wish to thank Priscilla Frost Milliman, John Frost, Jr. and William Geiger, descendants of A. B. Frost, for allowing me to undertake this project and for giving me their trust and confidence so completely.

Special thanks also go to Marguerite Daggy and to Emily Daggy Vogel, daughters of Frost's best friend Augustus S. Daggy, for the use of letters, photos and other material so vital to the preparation of this work.

Ellen Dunlap and Leslie A. Morris of The Rosenbach Museum and Library were especially helpful. Linda Matthews and Kathy Knox from Emory University's Robert W. Woodruff Library assisted in many ways. It has been particularly gratifying for my wife and me to renew our friendship with Dr. Thomas H. English, of Emory University, and to have him assume such an active role in the research and publication of this volume.

For permission to excerpt letters from Lewis Carroll to A. B. Frost, and to use photographs, I am grateful to A. P. Watt, Ltd. on behalf of the Trustees of the C. L. Dodgson Estate.

Kathleen A. Foster, of The Pennsylvania Academy of the Fine Arts, was exceedingly generous with her advice on the Eakins-Frost phase of the project. Archivist Cheryl Leibold, of The Pennsylvania Academy, graciously shared quotations from the Frost-Eakins correspondence. Eakins scholar Maria Chamberlain-Hellman generously shared her extensive research.

Edward J. Comolli, Calvin S. Koch, Albert Stickney, Francis M. Zachara and The Morristown Club allowed me to reproduce works from their collections. Stuart P.

Feld, Michael Frost, and Ernest Hickok helped me to locate and reproduce many of the Frost works shown in this book. Dr. Jay Weiss provided criticism, advice and encouragement. Roger L. Conover and Martin Bressler provided extensive research on the final days of Arthur B. Frost, Jr.

A special word of thanks surely goes to my editor, Roberta Kefalos, for her patient thoroughness, and to my publisher, Pete Wyrick, of Wyrick & Company, for his willingness to undertake this project.

Twenty-five years ago Charles Guzzo, of Parker Studios, Bloomfield, N.J., did most of the color photography for the first *A. B. Frost Book*. Now his son, Charles R. Guzzo, has done most of the color photography for *this* edition. Their professional skills are greatly appreciated.

Finally, I thank my wife, Mimi, for her patience, encouragement and valuable suggestions.

HENRY M. REED

CHAPTER ONE

The Most American of American Artists

*W*ere A. B. Frost known to us today as simply the dean of American illustrators, as well as America's outstanding sporting artist, a definitive treatise on his life and work would be a worthwhile project on these attributes alone. When we add to these qualities his skill as a fine painter and his irresistible style as an author and humorist, we find in A. B. Frost the outstanding chronicler of a broad segment of a vanished era.

While Frederic Remington, Charles M. Russell and others depicted that great period in our history involving the West—our frontiers and vanishing Indian civilization— A. B. Frost focused on the imagery of the Eastern scene: farmers, barnyards, plantation life, creatures and birds of the marshes and uplands, and the men who hunted them.

Following Frost's death in 1928, the Philadelphia *Evening Public Ledger* said:

> A generation that finds enjoyment in the slinky horrors of contemporary illustration or that sees something significant in the sketchy, grotesque, and sometimes extremely bewildering work of artists who "go modern" because they can not learn to draw would view Mr. Frost's work as somehow meaningless. Yet it was Frost who, by his great skill, talent, and patience, actually let one-half of the country know how the other half lived. The people he drew were real people. His animals were the very creatures of barnyards and meadows. No other artist was ever able to make a sky seem so clear or a reach of open natural land so true to reality. Frost was a great draughtsman, who preferred truth to fads. Few of his sort remain.

A. B. Frost was the primary illustrator of more than one hundred published books. Among the notable authors whose works he illustrated were Lewis Carroll, Charles Dickens, Joel Chandler Harris, Mark Twain, Theodore Roosevelt, Frank Stockton, William Thackeray, and others. For nearly fifty continuous years his illustrations appeared in the leading magazines, including *Harper's*, *Scribner's*, *Collier's*, *Century*, *Puck*, and *Life*. His own books—*Stuff & Nonsense*, *The Bull Calf and Other Tales*, and *Carlo*—were recognized as masterpieces of comedy.

The New York *World*, in an editorial obituary, wrote:

> A capital draftsman, racy of the soil as Mark Twain or Uncle Remus (both of whom he illustrated), unembittered, gusty as an Elizabethan, Frost will remain as one of the best America has produced. To pass from the shoddiness of the present-day "comic" to Frost's work is like coming out of a cheap cabaret into a delightful performance of Gilbert and Sullivan.

It would be shortsighted, however, to measure Frost's artistic talent solely in terms of "illustrator" or comic "caricaturist." His serious art, although less well known, was strongly influenced by his distinguished teachers, Thomas Eakins and William Merritt Chase. *Metropolitan* magazine stated in April 1905:

> As a painter in oil, Mr. Frost has exhibited both here and abroad. His contributions in this medium to the Paris Exposition in 1900 won for him the unstinted praise of the most exacting critics of the French capital.

An attempt to single out any part of Frost's prodigious lifelong output as his most noteworthy work would be almost impossible. However, the *Shooting Pictures* portfolio, published by Charles Scribner's Sons in 1895, and the unforgettable Brer Rabbit from *Uncle Remus* would certainly have to be near the top of such a list.

The *Shooting Pictures* portfolio is a set of twelve lithographs of various hunting scenes. These prints are the most eagerly sought Frost collector's items and are very difficult to find. Fortunate indeed, is the collector-sportsman whose walls are adorned by these colorful and exciting portrayals of his favorite pastime, where Frost has captured the tense instant when the quail is about to flush under the cold moist nose

Portfolio binding for *Shooting Pictures*, 1895.

of the quivering pointer, or when the ducks are suspiciously circling, getting ready to stool over the decoys of the nervous hunter whose heart is pounding as he crouches low in his blind.

Theodore Roosevelt, a great sportsman and outdoorsman during the 1880s and 1890s, prior to becoming our nation's president, wrote to Frost in 1885:

Dear Mr. Frost:

In the words of the immortal bard of Avon, damn the expense! I want at least *five* pictures; and six if you can give them.

I think it will be an immense improvement to have the bear in the foreground; if not too much trouble have the figures portraits—myself giving the shot, and my companion whose photograph you have kneeling beside me. (It is the photograph of the man kneeling with a fur cap; he has a dark moustache). Don't bother yourself about either; the cowboy's portrait is unimportant.

The mountain ram picture was first rate; the Bad Lands have just the eccentric character you gave them; indeed the likeness was wonderful. Don't tone it down too much; the rocks ought to look queer and bizarre.

Most truly yours,
Theodore Roosevelt

Just what is there about Frost's art that attracted so much attention back in 1874, when his first illustrations were published, and which has continued through the years as his drawings have illustrated some of the classics in American literature?

Frank Stockton referred to Frost as "the most American of American artists." Frost was completely honest in his work; his characters are absolutely real "everyday folk" without glamour or pretense, and yet these attributes alone are far from sufficient prerequisites for recognition. Many of Frost's characters have an indescribable qual-ity—the sense that something is on the verge of erupting, as he captures that electric instant of suspense just before the explosion. And the articulation of the body! He could draw a man with his back to the observer, dressed in a sack suit and you can practically see the expression on the subject's face. Whether depicting complete relaxation or quivering tension, he captures form and feeling with just a few strokes from his sure, swift fingers.

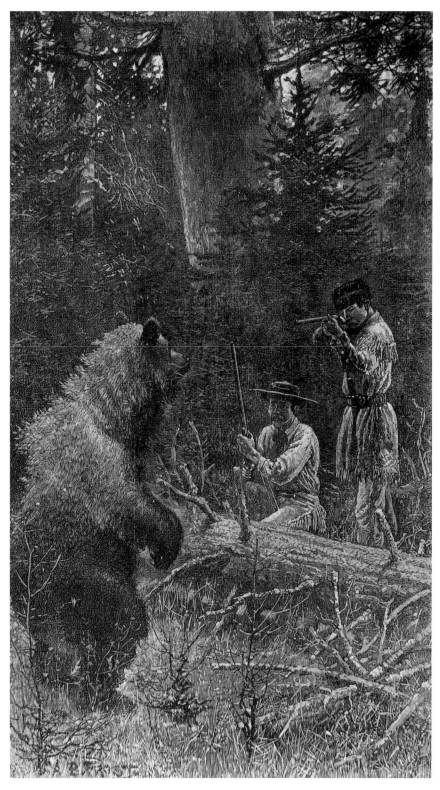

Close Quarters with Old Ephraim. Illustration from Theodore
Roosevelt's *Hunting Trips of a Ranchman*, 1885.

There is one small oil painting in particular, entitled *Outdoor Sacrament*, that depicts a prayer meeting involving more than sixty figures sitting, kneeling, or standing in various positions of prayer or meditation. The artist captured the solemn reverence of the occasion, including the impending downpour from heavy, rain-filled clouds rolling down over the majestic mountains. Yet during the same time in his career came his unforgettable pictorial story of the cat who ate rat poison, scenes from which are such wild, hilarious episodes that the whole story leaves the viewer weak and breathless from laughter.

His sketchbooks are replete with pencil caricatures of human forms in various poses, reclining, sitting, standing, talking, screaming, but almost always on the verge of action. There is a study of a shabbily dressed man, hand clutched to his throat with a wild look in his eye, who seems limply suspended like a puppet on a string—staggering, reeling, and flopping about in the most realistic manner. And dogs, he loved dogs. He left page after page of dog studies—hunting dogs pointing, of course, but also pencil sketches of dogs sleeping, curled up, and stretched out. It is said that whenever Frost went to the home of a friend who owned a dog, he immediately asked for a sheet of paper and dashed off a little gem which he invariably signed and handed to the dog's master.

In Joel Chandler Harris' immortal *Uncle Remus* series, A. B. Frost truly earned his reputation as a master draftsman, and his drawings helped establish Brer Rabbit as one of the classic characters in American literature. In the introduction to his book *Uncle Remus, His Songs and His Sayings*, Harris credits his illustrator with much of the success of this edition of his book:

> Because you have taken it under your hand and made it yours. Because you have breathed the breath of life into these amiable brethren of wood and field. Because by a stroke here and a touch there, you have conveyed into their quaint antics the illumination of your own inimitable humor, which is as true to our sun and soil as it is to the spirit and essence of the matter set forth. The book was mine, but now you have made it yours, both sap and pith.

Success Comes Early

Nicholas Frost brought the family name to America and Eliot, Maine, around 1634, although he had made a brief visit to Boston a few years before. His son, Major Charles Frost, at one time military governor of Maine, was killed in an Indian ambush on his way to church on the Fourth of July, 1697, an occasion commemorated in 1897 by the Eliot Historical Society.

A. B. Frost's father, Professor John Frost, was born in Kennebunk, Maine, on January 26, 1800. He graduated from Harvard in 1822. The following year he became headmaster of the Mayhew School in Boston, where he remained until 1827, when he moved to Philadelphia. On May 4, 1830, he married Sarah Ann Burdett in a ceremony conducted by Ralph Waldo Emerson, minister of the Second Church (Unitarian) in Boston. In 1838, he was appointed professor of belles lettres in the Central High School in Philadelphia. He received an LL.D. degree from Franklin and Marshall College in 1843. Beginning in 1845, he devoted his time exclusively to histories and biographies, publishing over three hundred of them, with the assistance of a staff of writers. Professor Frost died on December 28, 1859, leaving his large family a fine reputation, but little money.

One of the most important bearers of the Frost name in this long and distinguished list of Americans is the late renowned poet, Robert Frost, a distant cousin of A. B. Frost.

Arthur Burdett Frost, born January 17, 1851, was one of ten children; however, only two survived beyond the artist's teen-age years. His sister, Sarah Annie Frost, became an author. Her most notable work, *Almost a Man* was illustrated by her

brother Arthur. Frost's brother, Charles, became the owner of *Godey's Ladies Book*, in which his father had maintained an interest, and authored a few books of his own under the pseudonym of C. S. Ribbler. He also wrote the jingles for his brother Arthur's first book, *Stuff & Nonsense*, and originated a perpetual calendar, as well as Frost's *Comprehensive Calendar*, which is still being published.

In 1874, Arthur Burdett Frost was just a struggling young lithographer, and not a very good one either, when Dame Fortune struck like a bolt of lightning and catapulted him into immediate fame and prominence.

Charles Heber Clarke, humorist and author (writing under the pseudonym of Max Adeler), was completing the manuscript for his new book *Out of the Hurly Burly* when his brother William J. Clarke, a friend of Frost, suggested that Arthur might have talent enough to do a few sketches for the book. A few sketches indeed! The book came out with nearly four hundred illustrations, almost all of them by young Arthur Frost.

The book was an immediate sensation and went on to sell over a million copies. The author, even before publication, must have had some premonition of success for both his book and the career of his youthful illustrator when he made the following remarks in the book's preface:

> If this little venture shall achieve popularity, I must attribute the fact largely to the admirable pictures with which it has been adorned by the artists whose names appear upon the title-page. I wish to direct attention especially to the humorous pictures of Mr. Arthur B. Frost. This artist makes his first appearance before the public in these pages. These are the only drawings upon wood he has ever executed, and they are so nicely illustrative of the text, they display so much originality and versatility, and they have such genial humor, with so little extravagance and exaggeration, that they seem to me surely to give promise of a prosperous career for the artist.

The author's prefatory remarks were understatements compared to the opinions of the press which later appeared. In the Philadelphia Evening *Bulletin*:

> The illustrations are much the best that have ever been given in any American book of humor. There are nearly four hundred of them, most of which were designed by Mr. Arthur B. Frost, a young man whose genius has had its first good chance in this

work, and who is sure to become famous as a designer, especially in the line of the grotesque and comical.

The Wilmington *Commercial*:

The illustrations are profuse, and they are, nevertheless, excellent in design and execution. Most of them are by Mr. A. B. Frost, whose success is such as to put him at once in the foremost rank of American humorous artists. They really illustrate the text, and add in an important degree to its sum-total of genial pleasantry.

From the Philadelphia *Item*:

We have not laughed so much in a year. Pure fun, lots of fun, greet you on every page, and more amusement and entertainment can be found in this one volume than any other half-dozen comical books we have read this season. It contains 400 of the best American illustrations we have ever seen.

Frost did not bask in the warmth of his new-found fame and notoriety, for he was such a shy and retiring individual, never completely satisfied with his work, that celebration or exuberance was completely inconsistent with his personality. Instead, he immediately plunged into his career of nearly fifty years of continuous hard work and a prolific output of drawings, paintings, sketches, and illustrations.

What little pleasures he allowed himself were confined to his favorite outdoor pastimes—gunning with his friends in the marshes and uplands, rowing in the regattas with the National Association of Amateur Oarsmen on the Schuylkill River, or work-outs at the Philadelphia Fencing and Sparring Club, of which he was a member.

After the initial success of *Out of the Hurly Burly*, and before he was thirty, he had already illustrated the following books:

1876 *One Hundred Years a Republic* by Daisy Shortcut and Arry O'Pagus
1876 *Elbow Room* by Max Adeler (Charles Heber Clarke)
1877 *Almost a Man* by S. Annie Frost (his sister)
1877 *American Notes and Pictures from Italy* by Charles Dickens
1879 *Random Shots* by Max Adeler

"Well, one day a few months ago," continued Smiley, without noticing Mr. Par-ker's ill-nature, "he saunter-ed into the studio of the celebrated marine painter Hamilton, in Philadelphia. The artist was out at the moment, but standing upon the floor was a large and very superb picture of the sea-beach, with the surf roll-ing in upon it. The general stood looking at it for a while, until his mind wan-dered off from the present, and under the influence of the picture he was gradually

impressed with a vague notion that he was at the seashore.

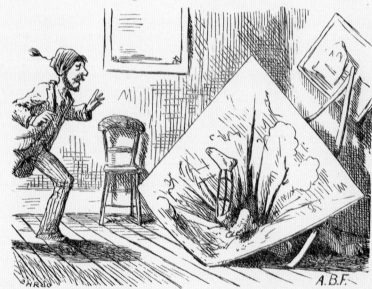

So, still gazing at the painting, he slowly removed his clothes,

Illustration from Max Adeler's *Out of the Hurly Burly.* 1874.

In 1875, Frost was working on the *The Daily Graphic*, and the following year he entered the studio of Harper & Brothers under the tutelage of Charles Parsons, who had gained lasting fame as the delineator of many of the Currier & Ives clipper ships. Interrupted briefly by a year studying and working in London in 1877–78, and by his studies at the Pennsylvania Academy of the Fine Arts, Frost's tour of duty in the Harper's art department spanned more than a decade, during which time he worked side by side with E. A. Abbey, C. S. Reinhardt, John Alexander, Thure De Thulstrup, Granville Perkins, Howard Pyle (at whose wedding Frost was best man), E. W. Kemble, Frederic Remington, and numerous other well-known artists.

Frost made lasting friendships in London where he came under the wing of George H. Boughton, who had acquired a reputation as a fine painter following an early career as an illustrator. The two subsequently corresponded for many years, during which time Boughton alternately offered him severe criticism and sincere encouragement. Another great friendship was made with the illustrator Fred Barnard, who was acquiring a reputation as the logical successor to famed British illustrators Cruikshank and Leech. Barnard's letters to Frost, most of which are illustrated with brilliant sketches, are priceless gems of wit displaying an unforgettable warmth of character.

While in England, Frost put forth a few efforts of his own that are worthy of mention, most notably the set of illustrations for Charles Dickens' *American Notes and Pictures from Italy*, of which he was co-illustrator with Gordon Thompson for one edition, and with Thomas Nast for a second edition.

However, the most significant part of Frost's trip to London came one cold foggy morning when the postman left the following letter in his mailbox:

The Chestnuts, Guildford, Jan. 7/78

Dear Sir,

Excuse the liberty I am taking in addressing you, though a stranger. My motive for doing so is that I saw a page of pictures, drawn by you in "July" last month, on "the Eastern Question" as discussed by 2 bankers, which seemed to me to have more comic power in them than anything I have met with for a long time, as well as an amount of

good drawing in them that made me feel tolerably confident that you could draw on wood for book illustrations with almost any required amount of finish.

Let me introduce myself as the writer of a little book (*Alice's Adventures in Wonderland*) which was illustrated by Tenniel, who (I am sorry to say) will not now undertake wood-cuts, in order to explain my inquiry whether you would be willing to draw me a few pictures for one or two short poems (comic) and on what sort of terms, supposing the pictures to range from 5 × 3½ downwards to about half that size, and to have about the same amount of finish as Tenniel's drawings usually have.

> Believe me
> Faithfully yours,
> C. L. Dodgson
> [Lewis Carroll]

It had already been thirteen years since the appearance of Carroll's immortal *Alice's Adventures in Wonderland* and six years since publication of *Through the Looking Glass*, both volumes brilliantly illustrated by Tenniel. Were not Lewis Carroll and John Tenniel as inseparable as tea and crumpets?

If, after reading the famous author's letter, Frost had not already seen examples of Tenniel's illustration, he soon took steps to familiarize himself with the British illustrator's technique. Many years later, Frost's library was found to contain a rather worn copy of *Aesop's Fables*, published in London in 1868 and illustrated by John Tenniel, with the bookplate sticker of Arthur B. Frost pasted on the flyleaf. Whether Mr. Frost or Father Time was responsible for the worn binding, it appears obvious that A. B. Frost was paying careful attention to Mr. Tenniel's methods of illustration. And so was Mr. Tenniel watching his new rival, A. B. Frost!

In a letter to Frost dated February 7, 1878, Carroll mentions that he had shown Tenniel a copy of Frost's first book illustrations in *Out of the Hurly Burly*. He writes:

> ... But I sent the book, at the time, to my friend Mr. Tenniel for an opinion: and I think I may, without breach of confidence, copy what he said. I would not do it if it had been written in a harsh tone, but I think it will not wound your feelings, and possibly, now that you have reached a higher level, you will agree with some of his criticism. He says "... The designs of Mr. A. B. Frost appear to me to possess a

Lewis Carroll. Rosenbach
Museum and Library,
Philadelphia.

certain amount of quaint and grotesque humour, together with an *uncertain* amount of
dexterous drawing, which might no doubt be developed into something very much
better, but which at present—as it seems to me, judging by the book—somewhat crude
and commonplace in execution; but the pictures are obviously very slight, and perhaps
it is hardly fair to give an opinion."

It is well known that Sir John Tenniel's dissatisfaction with the quality of the
woodcut engravings for *Alice in Wonderland* resulted in the scrapping of the entire
first edition of that classic. Had Frost known of those difficulties among author,
illustrator and engraver and of the voluminous correspondence that would soon engage
him, he certainly would have refused the involvement with Dodgson. Nevertheless,
this was a major, world renowned author, and the young American illustrator couldn't

Drawing by Lewis Carroll showing the author's suggested illustration for *Rhyme? & Reason?*, c. 1882. Rosenbach Museum and Library, Philadelphia.

afford to reject the commission. In 1878, Frost began his drawings for the woodcuts for Lewis Carroll's *Rhyme? and Reason?* which finally made its appearance five years later, in 1883.

During this period Frost had to endure and respond to meticulous criticism of each drawing he submitted, including redrawing some many times. The seemingly endless correspondence with Lewis Carroll continued through the period of Frost's studies at the Pennsylvania Academy and into the early years of his marriage. Not only was every drawing criticized and corrected, but the thickness of the line was occasionally altered, to be made thicker or thinner. For Frost, the ultimate humiliation must have occurred when Dodgson, who fancied himself to be quite the amateur illustrator, actually designed and sketched some of the illustrations for Frost to copy.

Illustration from Lewis Carroll's
Rhyme? & Reason?, 1883.

While alone in London, Frost had a chance to do some careful thinking about both his career and his future, and he had been given the opportunity to compare his own artistic merits with those of his English colleagues. Convinced that he needed further study and instruction, Frost returned home, more dedicated to America than ever, and thoroughly convinced of the part his native land was to play in his future work.

Although few, if any, portraits are known to have been painted by Frost, the influence of his distinguished teacher, Thomas Eakins, affected his figure work tremendously. It was around this time at the Pennsylvania Academy of the Fine Arts that Eakins' life classes created a storm of controversy over his studies of nude male and female figures. It was under Eakins that Frost perfected his draftsmanship in the articulation of body movements.

call. He comes within ten feet of the
porch. I never knew they were so tame.
He wakes me up every morning.

There is one of the servant girls
who has a most peculiar
and startling figure.
I never saw anything quite
so remarkable.

I think you would be
pleased if you could see
my get-up. I have bought
a big straw hat and
have borrowed one of those
striped thin coats like the
one I wear 'round the
studio. it is miles too
short and I think the
entire thing, flannel
shirt and all, is rather
fine. it suits my
rowdy instincts to go
about this way.

When I have that farm
I will revel in out-land-
ish costumes.

Do write when you

Letter from A.B. Frost to his fiancée, Emily L. Phillips (later, Mrs. A.B.
Frost), 1882, in which the artist included sketches, as he frequently did in
his personal correspondence.

Opening a studio at 1330 Chestnut Street in Philadelphia, Frost plunged immediately into illustrations for *Random Shots,* his third book for Max Adeler, plus the backlog of work which had accumulated during his trip abroad. Several hunting trips to Swiftwater in the Pocono Mountains with his friend Norris De Haven followed, including one major but unsuccessful hunting and sketching trip to Canada which pointed to signs that Arthur B. Frost—whose heart longed for Philadelphia—was not long for this world as a bachelor.

A. B. Frost first became acquainted with his future wife around 1878, when both were students at the Pennsylvania Academy of the Fine Arts.

Emily Louise Levis Phillips was born January 19, 1852. She was the daughter of Moro Philips, a wealthy Philadelphia industrialist, and she was named after her mother. Her great-grandfather, James Ash, had been a notable Philadelphia gentleman in the early nineteenth century. A portrait of James Ash painted by the distinguished early American portraitist, John Neagle, was once a prized family possession.

Emily Phillips studied art in Germany at Dresden and Pillnitz and her skill advanced to a professional level of excellence. In 1883, Emily Phillips and A. B. Frost were together among the illustrators of the book *New England Bygones* by Ellen H. Rallings, published by J. B. Lippincott. Miss Phillips's artistic talent, not to be outdone by her now well-known fiancé, was attracting a little attention of its own, though in a slightly different way, as evidenced by this communication from a *Harper's* reader:

Madam:

. . . I have been much interested in studying your picture in the last *Harper's Weekly* entitled "The Apple Harvest." The general detail and execution of the picture are so pleasing to one that I cannot refrain from calling your attention to one defect, viz.: the impossibility of carrying a basket of apples with so little apparent effort as the girl in the foreground is making. The apples would weigh at least fifty or sixty pounds . . .

A. B. Frost and Emily Phillips were married on October 19, 1883, and set up housekeeping in Huntington, Long Island.

Eakins and Frost

*T*he idea of another A. B. Frost book started all over again the instant I glanced through a copy of the catalog for Sotheby's December, 1987, American Painting sale. There it was—lot number 116—"Thomas Eakins (1844–1916), *Hauling The Seine, Shadfishing Off Gloucester, [N.J.]*" In a flash I recalled a letter in the Frost archives from A. B. Frost to his fiancee, Emily Phillips, telling her of their invitation from the "tribe of Eakins" to a "shad fishing spree" at Gloucester, N.J. I quickly realized that the Eakins painting soon to be sold at Sotheby's visually documented a strong historical connection between A. B. Frost, his fiancee and Thomas Eakins. Without delay I began, mentally, to scrape assets and buying power together, but alas, I feared that such an important Eakins painting should fetch a substantial sum. After all, at Sotheby's previous American Painting sale, the Eakins portrait of James Wright, another one of his students, had brought the staggering sum of $2,420,000, a new auction record for an Eakins painting.

As it turned out, the Eakins shad fishing picture finally sold for $88,000, within its pre-sale estimate of $80,000–$120,000. Despite some sleepless nights, I simply lacked the means to obtain it. Nevertheless, the event was the catalyst which started this new volume.

"Eakins may have known Arthur B. Frost (1851–1928) as early as his high school days," wrote Theodore Siegl in a catalog for the Philadelphia Museum of Art, "for Frost's father was a professor of literature at Central High School; or they may have met around 1872, during the period Eakins was painting his rowing pictures, when

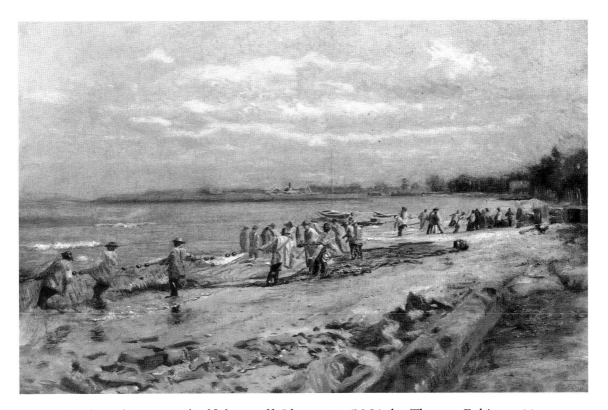

Hauling the Seine, Shadfishing off Gloucester (N.J.), by Thomas Eakins, 1882, oil on canvas.

Frost, a member of Undine Barge Club, rowed bow in a four-oared gig race. Certainly, by the time he became a member of the Philadelphia Sketch Club, where Eakins conducted an evening life class from 1874 to 1876, he and Eakins knew each other. Later, Frost was enrolled as a student at the Academy from September 1878 through 1881, when Eakins was teaching there."

At this time, Frost and Eakins shared a common interest in the outdoors. Sporting activities, such as scenes of hunters pushing for railbirds and plover in the tideland marshes, provided subject matter for both of them.

Eakins's *Pushing for Rail,* now in the collection of the Metropolitan Museum of Art, was a major influence, since Frost later painted or drew several versions of this subject. His best known is *Rail Shooting,* from Scribners' *Shooting Pictures* portfolio. The scenes of hunters and dogs for which Frost acquired his reputation among sports-

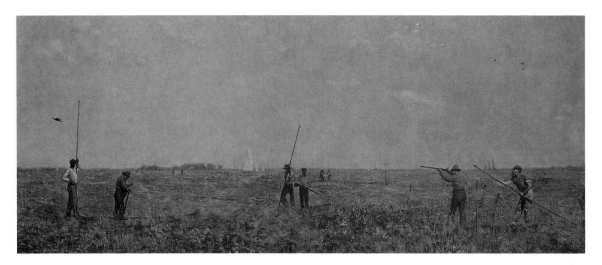

Pushing for Rail, by Thomas Eakins, 1874, oil on canvas. The Metropolitan Museum of
Art, Arthur Hoppock Hearn Fund, 1916.

men were a result of his own personal experiences and the influence of Thomas Eakins.

Among Eakins's major paintings of the time were his scenes of rowers in their sculls
on the Schuylkill River. Frost was a member of The Undine Barge Club, and in letters
to his fiancee, mentioned his habit of early morning rowing. Among the Frost family
papers remains the "Official Programme" of the Eighth Annual Regatta of the National
Association of Amateur Oarsmen on the Schuylkill River on July 7, 1880, with the
winners' names and times carefully written in Frost's hand.

Frost family correspondence, much of it now over a century old, provide some
interesting insights into the relationship of Eakins with his students. Fortunately, the
correspondence was carefully preserved, for this body of letters has also been the
primary source of much that is known about Frost and his family. In April, 1882,
Frost wrote to his fiancee:

> I am very glad Eakins has attended to the Circus tickets. I have thought of it several
> times; you know I couldn't get them before I left. They were not for sale then. I think
> it would be rather nice to go up there some Sunday afternoon if it won't raise a
> commotion at home. We could get photographed in the sunlight no doubt, nice sunlight
> heads: nothing practical about me is there? I have an eye on the main chance all the
> time. My! I wish Eakins would give you the Zither Player, though you might not like

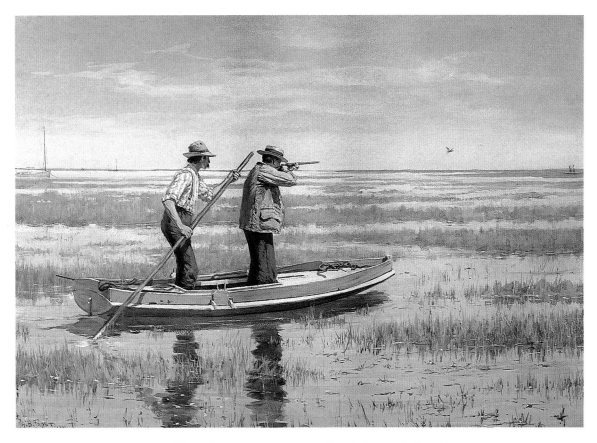

Rail Shooting, c. 1901, gouache. Private Collection.

to be under obligation to him for so valuable a picture. Maybe he will give you some other work. He is a very nice fellow and I enjoyed our visit there the other evening. I wish I could entertain him at the Studio with the gang but I can't afford any sprees but ours now-a-days.

Why would Eakins give Emily Phillips *The Zither Player*? Eakins frequently used his students for models, and sometimes rewarded them with an original study or a sketch. The model in his *Young Girl Meditating*, done in 1877, bears a resemblance to Emily Phillips, a student in his life class at the Pennsylvania Academy of the Fine Arts from 1876 to 1880. It is highly doubtful that Eakins would have given a work of such importance as *The Zither Player* to his model. Aside from a portrait of A. B. Frost, the only works by Eakins known to have been in Frost's estate were an oil sketch of a black boy and an oil study of a red clay horse, both lost.

The Zither Player, by Thomas Eakins, 1876, watercolor. Art Institute of Chicago.

There are two watercolors from this period which clearly illustrate Eakins's influence on his student. Frost's *Girl with Geranium Plants* bears a similarity to Eakins's *Young Girl Meditating*. A. B. Frost's *The Candlestick Girl*, 1883, is an example of how well the student learned the lessons of the master. Although Frost considered this watercolor overworked and unsuccessful, the use of the seated model wearing the old-fashioned flowing gown, the antique American furniture, the early American silver, and the treatment of the colorful carpet and wallpaper all are techniques shown in many of Eakins's watercolors, particularly his *Seventy Years Ago*, 1877.

On March 2, 1883, from 1330 Chestnut Street, Frost wrote to his fiancee:

> I started another idea for the Tennis this morning, making two figures instead of one and closer to the net. I worked on that 'til half-past ten. Then Kelly came and we talked for an hour and he really helped me a great deal; he liked *your* candle-stick girl better than mine and thinks you will get a good thing out of it, but he didn't like your red girl and told me where it was out of tone. I think he was right about it, and that you can fix it very well. My candlestick girl is carried too far to be altered, so I will let her go. I think when Kelly criticizes from his own stand-point he is very good. We went out at half-past eleven and went to Haseltines and then I went down the street, bought some photograph plates and those animals in motion by Muybridge.

Eakins's exhortations to his students regarding truth in art, naturalism, strong clear vision, and good solid work are well-known. In 1869, as he completed his studies under Jean-Léon Gérôme in Paris, Eakins spent some months in Spain on his way home to Philadelphia. In a letter to his father he wrote: "O, what satisfaction it gives me to see the good Spanish work, so good, so strong, so reasonable, so free from every affectation." He hated romantic, mawkish sentiment, and demanded truth and reality.

It is impossible to know whether Arthur B. Frost was already in possession of these same traits when he became a student of Eakins, but it can be said with certainty that Frost and Eakins shared a nearly identical artistic vision. And, as we shall see later in this volume, Frost's dogged insistence on truthful realism and a naturalistic approach to art became obsessive as he was introduced to modern art in Paris early in the twentieth century.

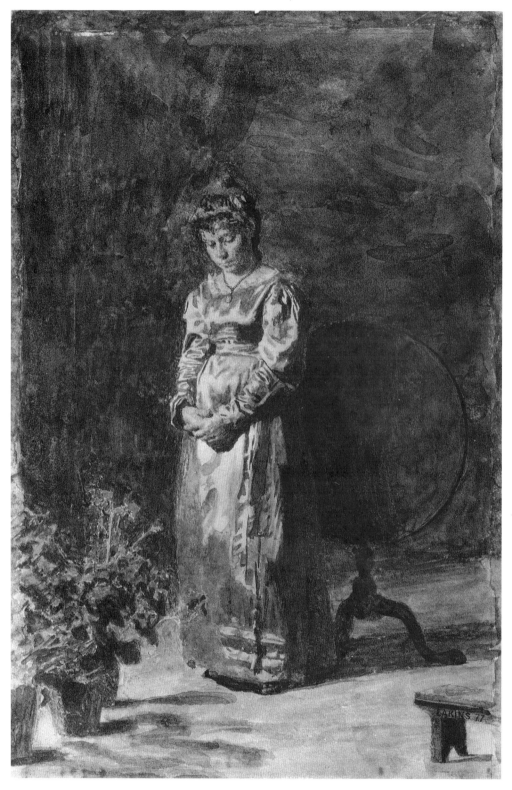

Young Girl Meditating, by Thomas Eakins, 1877, watercolor. Metropolitan Museum of Art, Fletcher Fund, 1925. The model in this painting bears a close resemblance to Emily Phillips.

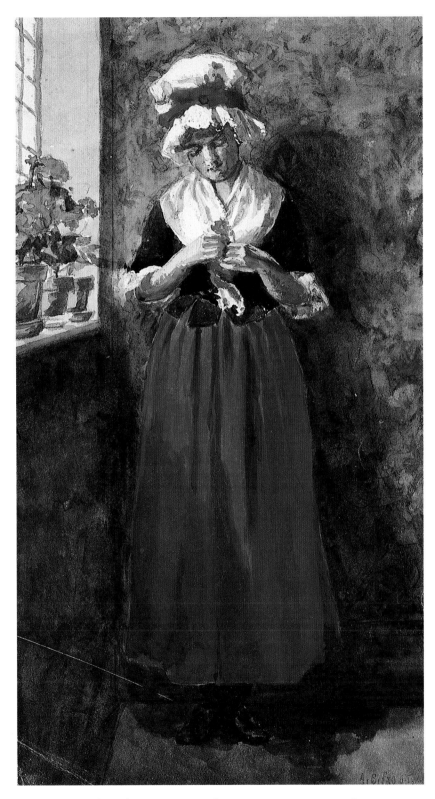

Girl with Geranium Plants, c. 1881, watercolor.
Private Collection.

The Candlestick Girl, 1883, watercolor.
Private Collection.

Seventy Years Ago, by Thomas Eakins,
1877, watercolor. The Art Museum,
Princeton University. Gift of Mrs. Frank
Jewett Mather, Jr.

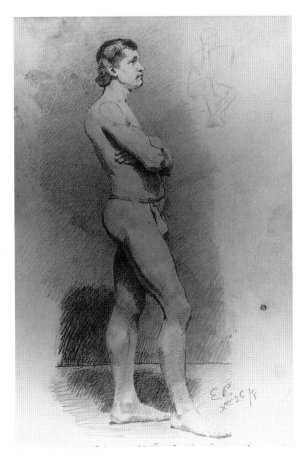

Figure sketches by Emily Phillips, 1878, pencil on paper. Private Collection. Drawings from the artist's sketchbook, done while she was a student at the Pennsylvania Academy of the Fine Arts. The nudes are typical of the professional models Eakins used in his classes.

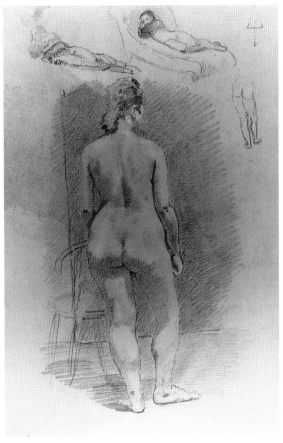

Emily L. Phillips, 1881, watercolor. Private Collection.

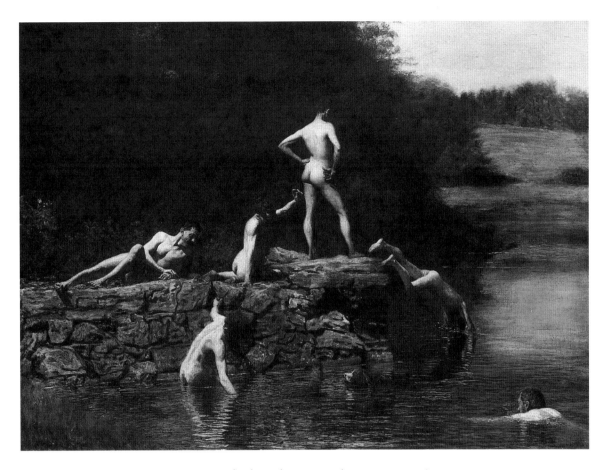

The Swimming Hole, by Thomas Eakins, 1883, oil on canvas.
Amon Carter Museum, Fort Worth.

Although the nude figure is virtually unknown in Frost's work, his masterful treatment of the draped or clothed human figure clearly shows the influence of his teacher in the muscular flexation and articulation of the body.

In 1883, Eakins began his painting *The Swimming Hole* with a series of photographs and an oil sketch depicting himself and a group of his students swimming in the nude. According to author Gordon Hendricks, in his book, *The Life and Works of Thomas Eakins* (New York: Grossman), 1974, Frost can be identified as the redhead in the foreground with his left arm holding onto the rock ledge. Eakins can be recognized as the swimmer in the lower right. Lloyd Goodrich, also the author of two definitive books on Eakins, disagrees, stating in a footnote that Frost was unavailable as a model for the work because he was married in 1883 and moved to Huntington, New York.

"Tompkins, there is nothing Arcadian about this; it is useless fer me to struggle with this picture in this light. We will go to Nature, Tompkins." Illustration from *A Glimpse of Arcadia* series, *Scribner's*, December, 1891.

Goodrich assigns a date of 1884-1885 to the completed *The Swimming Hole*. However, the initial photographs and oil sketch for the work (now in the Hirshhorn Museum and Sculpture Garden, Smithsonian Institution) were done in 1883, when Frost lived in Philadelphia and could have been one of the models.

Whether or not Frost permitted himself to be photographed in a nude bathing picture with several other Eakins students (in addition to Frost, Hendricks lists J. Laurie Wallace, George Reynolds, Jesse Godley, Eakins himself, and his dog Harry), he seems not to have taken his teacher's nude photography or figure painting very seriously.

A. B. Frost was apparently so amused by Eakins's *Arcadia* photographs and paintings of nude youths outdoors playing woodwind instruments that he later used the theme himself in a comic cartoon series for *Scribner's* entitled *A Glimpse of Arcadia*.

An interesting and amusing insight into Eakins's teaching methods can be found in a letter, dated November, 1881, from a student, Horatio Shaw, to his wife, Susie, as reported in Maria Chamberlain-Hellman's *Thomas Eakins as a Teacher* (New York: Columbia University Ph.D.), 1980:

I must tell you about Frost. You recollect I described him to you once. Well, when Eakins came around last night, he sat down and looked at Frost's work, then he began to point out where the figure was out of drawing, as a special favor I suppose for they seemed to be old friends, he took his brush and painted the figure over, made the body longer and put more action in the figure. Such a complete change made a smeary mess of it. That was just before a rest. After the rest when Eakins was gone, Frost sat down, shoved his hands into his pockets and sat and looked at his picture. Finally said "Well, that looks encouraging, don't it?" I haven't laughed so hard for a long time.

Several years later, Frost recalled the incident and reenacted it in a series of comic drawings entitled *Style* which was published in *Scribner's* magazine in December, 1891. The fictitious Mr. Slinger, the famous painter, bears a closer resemblance to William M. Chase, with whom Frost was studying at the time, than to Thomas Eakins. Both teachers were known to make corrections directly on the work of their students.

The Disgruntled Artist, pen and ink. Private Collection.

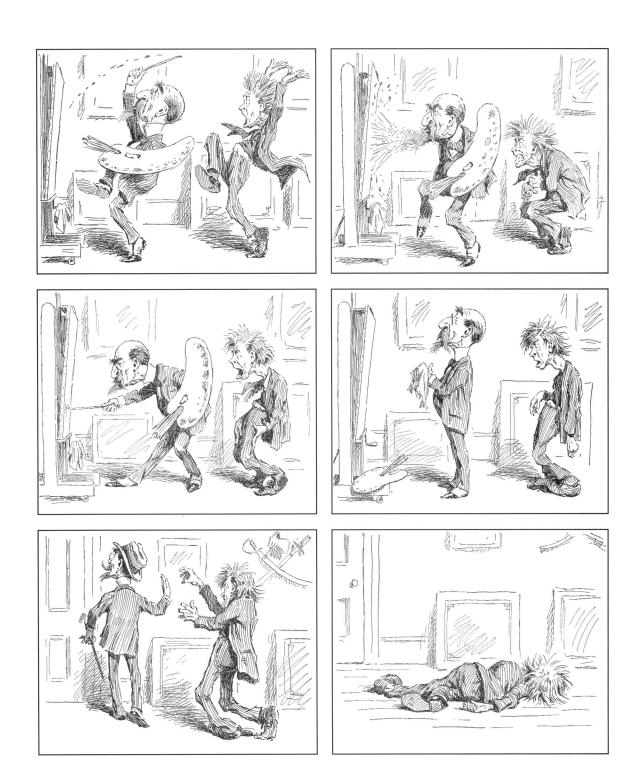

Style, a series of illustrations, *Scribner's,* December, 1891.

The story of Eakins's dismissal by the Pennsylvania Academy of the Fine Arts in 1886 for using a completely unclothed model is a well known chapter in art history. Lecturing to a life class composed of both men and women students, Eakins, always meticulous in his demand for accuracy in portraying human anatomy, suddenly removed the loin cloth from his male human model. The resulting furor led to his dismissal from the Academy. The Frosts, living at the time in Huntington, Long Island, seem to have been uninvolved in the affair. Sometime in 1887, the Frosts returned to the Philadelphia area, taking residence on a farm in nearby Conshohocken.

From Charles Bregler's Thomas Eakins Collection at the Pennsylvania Academy of the Fine Arts, two interesting letters have surfaced which further illuminate the relationship between Frost and his distinguished teacher. On May 19, 1887, Frost wrote to Eakins:

> I really do not see why you want to show Mrs. Frost and me your marriage certificate; certainly neither of us have ever questioned your marriage in any way.

On June 8, Eakins wrote to Frost:

> I have desired for many months to lay before you evidence of the falsity of some outrageous slanders . . . My reason for wishing to show you my marriage certificate, amongst other things, is that you as a well wisher may be in position to say to any doubter or inquirer, if you feel like it, that you know there was nothing irregular in our marriage which was in the Quaker form . . . it having been industriously rumored that Sue and I were unmarried.
>
> I still trust that you may call upon me shortly, and patiently look over what I wish you to, in remembrance of the trouble I have often taken to please you or advance your art.

It is apparent that one or both of the Frosts did go to Eakins's studio at their teacher's request, for it is recorded in Eakins's account book on July 19, 1887: "$150—Emily Frost's check for portrait of husband painted in 1886."

Within a few days, Eakins was on his way for the famous trip to North Dakota's badlands where he spent the rest of the summer living the life of a cowboy.

There are two portraits of A. B. Frost by Thomas Eakins still extant. One, a finished

version, is in The Philadelphia Museum of Art. The second, a less finished version, is owned by The Detroit Institute of Arts. A third Frost portrait survives—a copy after one of the Eakins portraits—creating a mystery, since the copy was once ascribed to the master himself.

In the Henry W. Lanier sale at the American Art Association Anderson Galleries, February 11, 1937, twenty lots of A. B. Frost paintings, drawings, and prints were sold. Included were two portraits of Frost ascribed to Eakins; both were ultimately acquired by The Detroit Institute of Arts.

The first, lot number 101 in the catalog, was described as a "Portrait of A. B. Frost by Thomas Eakins. 26¼″ × 21¼″. Original painting in oils. A fine and characteristic likeness." It sold for $600. As we shall see, this portrait was evidently not a genuine Eakins, but a copy.

The second portrait, lot number 102, was described as a "Portrait of A. B. Frost by Thomas Eakins. Original painting in oils. This is the first sketch made as mentioned in the note to the preceding description. Height 26 inches; width 18 inches." This lot was *correctly* ascribed to Eakins; it brought $300 in the sale.

In 1978, Theodore Siegl, in *The Philadelphia Museum of Art: The Thomas Eakins Collection* (Philadelphia: Philadelphia Museum of Art), 1978, wrote the following:

> Eakins's portrait of Frost is difficult to date. A label written by Mrs. Eakins and attached to the reverse of the painting says that it was painted about 1884. But in Eakins's account book (collection of Mr. & Mrs. Daniel W. Dietrich II) the following notation appears for July 19, 1887: "to Frost's portrait 150—Emily Frost's check for portrait of husband painted in 1886." This notation refers to another portrait of Frost, which is now in The Detroit Institute of Arts, but the Frost portraits are similar enough to indicate that both were painted in the same year. A second portrait of Frost in Detroit is a copy after the Eakins portrait there.

Gordon Hendricks, in his biography of Eakins, wrote:

> Arthur B. Frost, the redhead in *The Swimming Hole*, who was always reluctant to give Eakins credit for teaching him anything, was the subject of two portraits. One of

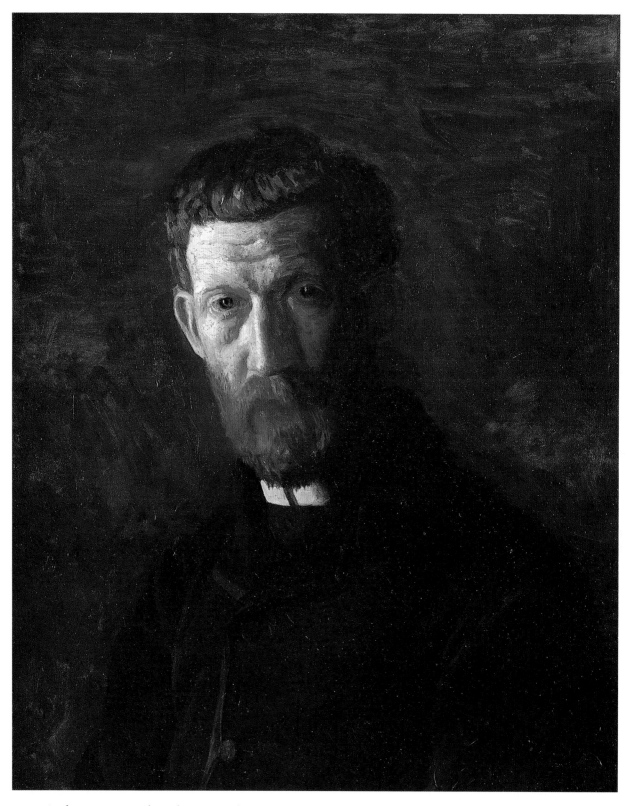

Arthur B. Frost, by Thomas Eakins, 1884, oil on canvas. Philadelphia Museum of Art. Gift of Mrs. Thomas Eakins and Miss Mary Adeline Williams.

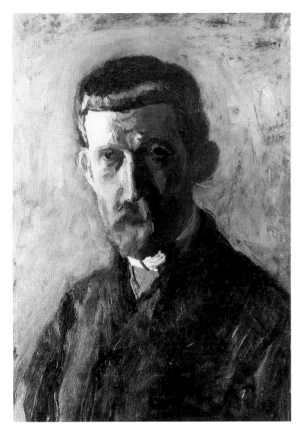 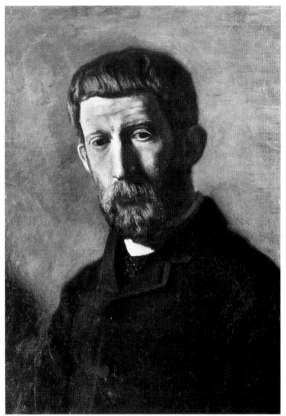

Arthur B. Frost, by Thomas Eakins, c. 1886, oil on canvas. The Detroit Institute of Arts, 1988. Gift of Dexter M. Ferry, Jr.

Arthur B. Frost, attributed to John Frost, oil on canvas. The Detroit Institute of Arts, 1988. Gift of Dexter M. Ferry, Jr.

them of about 1886, now in The Philadelphia Museum is finished, or perhaps over-finished, and the other, in The Detroit Institute of Arts, is unfinished.

The latter painting now hangs beside another portrait also ascribed to Eakins. But this other portrait is evidently a copy of Eakins Philadelphia portrait made by Frost's son John, perhaps during the time it was on loan to The Museum of Modern Art for the Eakins-Homer-Ryder exhibition in 1930. It was in 1930 that Henry Lanier published this copy in his biography of Frost, and ascribed it to Eakins apparently thinking that it was an exact reproduction and thus, effectively, an Eakins. J. Laurie Wallace had seen this copy in Frost's home, and an eyewitness tells us that he thought so little of it that he pretended not to see it. Mrs. Eakins and Charles Bregler, along with numerous Philadelphia Museum staff members, saw it in 1934, when it was shown in a Chestnut Street bookstore as part of a display for the Frost biography: "It is a very poor copy," Mrs. Eakins wrote Fiske Kimball, the Museum director, and Kimball

agreed with her. He assured her that in accordance with his promise, no copy had been made of the Museum's portrait. Perhaps it had been copied from a photograph.

Mrs. Eakins knew only the Philadelphia Museum's Frost portrait by her husband, but there is little doubt that another was produced. Eakins records how he got $150 for a portrait of Frost in 1887—and the Detroit portrait fills the bill. The price paid would have been reasonable for an unfinished portrait at a time when finished portraits were costing $500. The size (27″ × 22″) is too large for a sketch for a portrait, but appropriate for the first stage of a finished, full-size portrait. The quality of the Detroit portrait, although we know of no other Eakins portrait at this stage of completion, is high.

Gordon Hendrick's attribution of the copy to John Frost appears to be incorrect. The Frost archives now shed some final light on the mystery of the copy of the Eakins portrait of Frost in Detroit. On September 29, 1934, five years after the deaths of both of his parents, John Frost wrote to his father's lifelong friend, Augustus Daggy:

Dear Uncle Gus:

Do you remember my speaking about the Aikens [sic] portrait of Dad and saying that Mrs. Aikens [sic] claimed that it was a copy?

I was wondering whether when you get time you would write me and tell me of anything you might remember relating to the painting of the portrait so that I could put your letter with it to substantiate its authenticity, in case something may happen to me.

There is no record of a reply from Daggy. However, it is certain that had John Frost made the copy of the portrait there was no need for him to question Daggy about it. A more logical theory would be that Emily Frost bought the portrait in 1887 for $150, took it home, stretched a canvas, mounted it on her easel, and very innocently copied it. From it, she painted the finished version which Hendricks attributed to John Frost, her son.

How Hendricks could make this misattribution is a mystery. I clearly recall receiving Hendricks at my home while he was researching his book. I showed him the letter from John Frost to Gus Daggy and we discussed it. He must have forgotten the entire incident.

CHAPTER FOUR

The Golden Age of Illustration

*I*n early colonial times, the majority of illustrated books in America were imported from England. It was not until the latter part of the eighteenth century that a few American publishers began printing books with illustrations. In 1787, an edition of *Little Goody Two-Shoes* was published in Worcester by Isaiah Thomas, with a frontispiece credited to John Bewick.

During this period a New York physician, Alexander Anderson, was experimenting with wood engraving, and, in 1795, contributed thirty-seven woodcut engravings for the book, *The Looking-Glass for the Mind; or, Intellectual Mirror*, published by William Durell of New York. Anderson, who became known as the "father of wood engraving in America" remained for nearly fifty years the leading figure in this technique of book illustration.

While Charles Keene, George Cruikshank, Sir John Gilbert, and two or three others were acquiring reputations as important illustrators in England, there was practically no illustrator of stature on the American scene until the 1840s when the work of F. O. C. Darley appeared. Darley's work was first published in 1843 as a series Indian life scenes which he created from studies of a sketching trip to the West. The artist had little time, however, to pursue his early interest in the West, as his illustrations found their way into volumes by Washington Irving, James Fenimore Cooper, Nathaniel Hawthorne, Henry Wadsworth Longfellow, and many others.

In 1859, another fine illustrator came on the scene—Winslow Homer—who was destined to become one of the greatest American artists. His career as an illustrator was brief, and his principal work in illustration consisted of his Civil War scenes, which were published in *Harper's Weekly*. Homer continued later with brush, canvas and watercolor to make the great achievements for which he is remembered.

With the exception of Darley and Homer, American illustration around 1870 was generally erratic and of undistinguished quality, although thoroughly American in flavor, spirit and subject matter. It had been just a few years since Charles Parsons had left the firm of Currier & Ives, where he had been a lithographer and contributing artist, and had joined the art department of *Harper's*. Soon Parsons became head of the art department and was responsible for the illustrations in *Harper's Weekly*, as well as those in books published by the firm. Parsons assumed the responsibility of hiring and training artists, and his technical knowledge as well as his own talent— particularly as a painter in watercolors—soon created a staff of young artists, practically all of whom eventually became famous.

There was C. S. Reinhardt, senior member of the staff and an extremely capable artist; Edwin A. Abbey, who went on to fame in England as a Royal Academician; J. W. Alexander, who became a distinguished portrait painter; and, of course, A. B. Frost. Not long afterward, the unforgettable Howard Pyle joined the staff at Franklin Square, together with W. A. Rogers; T. De Thulstrup; F. Hopkinson Smith; W. T. Smedley; E. W. Kemble; the great Western artist Frederic Remington; and others.

Thus began the "golden age of American illustration" which lasted for the remainder of the nineteenth century and well into the opening years of the present century, roughly corresponding with the career of A. B. Frost, perhaps the outstanding figure of this period. It can be said without conjecture that this era in the history of American art began with Charles Parsons and his young staff in the dingy lofts of the *Harper's* art department in Franklin Square.

The year 1883 was busy for A. B. Frost. In addition to his staff work on *Harper's*, he illustrated the novel *Hot Plowshares* by Albion W. Tourgee; *Dialect Tales* by Sherwood Bonner; and *Rhyme? and Reason?* by Lewis Carroll, which was published

I Have a Horse. Illustration from Lewis Carroll's *Rhyme? and Reason?*, 1883.

in London with sixty-five illustrations by Frost and nine by Henry Holiday. Upon publication, the British author presented Frost a copy of the book with the following handwritten inscription on the half-title page:

ARTHUR B. FROST
from the author
in token of his sincere regard
and grateful remembrance
of the Artist's hand
which had made this book
what it is

Later, while working in his studio to complete five of the illustrations for Theodore Roosevelt's *Hunting Trips of a Ranchman*, Frost received the following letter from the well-known hunter, author and future president:

422 Madison Ave., New York, Feb. 26th '84

Dear Mr. Frost,

The fifth picture that I want is one I think peculiarly in your vein.

My cousin once wounded a buffalo which climbed up a very steep bluff; my cousin clambered after it, got his hands over the top and raised himself on them only to find the buffalo fronting him with lowered head two yards off. My cousin is a bearded man with spectacles and I have always thought that his face at that moment must have been a study. What do you think of making a picture out of that? It could be called "Tête-à-tête."

The buffalo, with lowered horn advancing, on a flat plateau, with cliff receding at left, and my cousins head and shoulder resting on his elbows and rifle in one hand appearing above edge. I will send you his photograph if you wish it, but it does not seem to me necessary, a bearded man with spectacles, and wild astonishment in his face. Write me what you think of it; before beginning it could I not see you?

Most truly yours,

Theodore Roosevelt

Needless to say, the illustrator followed his author's wishes and *Tête-à-tête* appears just as Roosevelt described it on page 250 of the book which was published by G. P. Putnam's Sons in 1885.

His work for *Harper's* was progressing nicely, too. Frost wrote to his fiancée during their house-hunting days just prior to their marriage:

New York, July 11, 1883

Dear Little Woman,

Things are just booming; I haven't been in such a good humour for fifteen years. First Mr. Parsons was *very* much pleased with the drawings. Thinks they are the best things I have done yet. He said a good deal about them and was very complimentary. Says he thinks I am getting the real thing for illustration. Next my comic page was a big success. They laughed over it a great deal and want a lot more as soon as I can do them; next, I got thirty dollars for the two comics, which wasn't so bad as they took me about three hours to do. Next, they want me to draw cartoons for them; offer me a mighty good price and will give me every help they can. We will talk it over and you

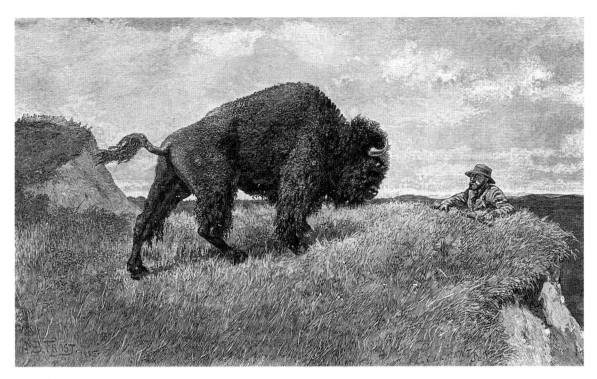

Tête-A-Tête. Illustration from Theodore Roosevelt's *Hunting Trips of a Ranchman,* 1885.

must think about it; it will certainly pay me over a hundred dollars a week and leave me time for other things, but we will talk about it.

Next, Mr. Parsons liked my idea for Prag very much and urged me strongly to stick out for a copyright, not to let them have anything to do with it without a copyright; he thinks it is a first rate scheme.

Next I saw Mr. Batchelar and he is a very nice fellow I should say, a plain man, printer. Found him setting type in his shirt sleeves. He took a fancy to me from my letter and lamented very much that he had rented his house but he has another and is going to show it to me next Saturday. He will build us a studio, but I find Jamaica is three miles from the water. We might as well live in Montclair, but I will go look at the place anyhow. Next, Mr. Parsons is going to drive me all about next Sunday week and knows of one place that must be lovely, but he thinks the rent is way up and out of our reach.—I have had a most successful day, dear Love, and feel very jolly. I am more pleased with my work than I can tell you. I think Mr. Parsons was very much pleased and looks for big things from me. He was very kind and nice and wants us to come out his way to live very much. I can see that plainly—

Cover of *Stuff & Nonsense*, 1884.

Frost and his bride were very happy and comfortable in their Huntington, Long Island, home. The Sound, with its duck blinds and good snipe shooting, was nearby, and he also had a chance to continue his favorite pastime of rowing. His fellow art student from the Pennsylvania Academy of the Fine Arts, Augustus S. Daggy—who was to become one of Frost's closest lifelong friends—lived nearby, and the two spent

hours together sketching and painting the dunes and shore-bird haunts. It was here that Frost and Daggy, easel to easel, worked happily together. Here Frost painted a charming little sketch inscribed, "Aug. 2nd 1884, First Attempt in Oil," and the Daggy family of Norwalk, Connecticut, have almost the identical scene on canvas painted by their father, also dated 1884.

At about this same time he was working on his second book for Lewis Carroll, *A Tangled Tale*, his first book for Theodore Roosevelt, *Hunting Trips of a Ranchman*, and his own first book, a delightful volume of comic sketches and verses entitled *Stuff & Nonsense*, published in New York in 1884 by Charles Scribner's Sons and in London by John C. Nimmo.

Frost's book was an immediate success. Demand for it was so great that it was reprinted in 1887. The second edition was also enormously successful, and today that second edition, with certain revisions, is much more difficult to find than the first.

Fred Barnard, well-known English artist and illustrator, wrote to Frost about *Stuff & Nonsense* in December 1884:

> . . . We have all enjoyed it immensely—the children were clean doubled up at the first start by the "cat" episode—and I can honestly assert that I have never laughed so much at anything of that same kind—the "qualms" coming on is enough to tick one off, to say nothing of the rollicking yarn to follow—the Kangaroo is Devilish good— In fact the book is a scream from beginning to end . . .

George H. Boughton, National Academician, and close friend of Frost when they were in London together, wrote in January 1885:

> . . . your book has been a very great success here—One small shop told me they have sold over 80 copies and that was before the holidays. Abbey told me about it before it was much about and I knocked off and got me a copy at once—he likes it enormously and I think it one of the best of all funny books—You are one of the few who carry *good drawing* all through distorted objects—most misguided folks think any kind of drawing will do for caricature—Mistake!
> I like you in this book far better than in your more serious work such as yours in

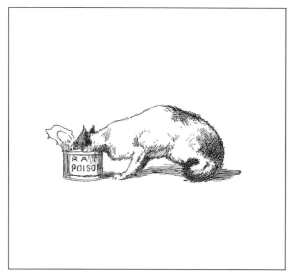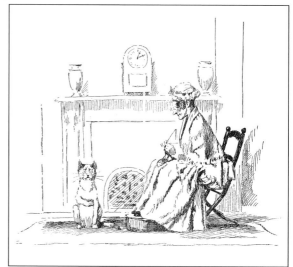
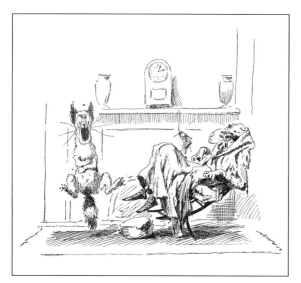

The Fatal Mistake—A Tale of a Cat. Illustrations from *Stuff & Nonsense*, 1884.

the Xmas *Harper's* where the work looks careworn and "tight", notwithstanding the evident pain you have taken to get it into shape. Excuse my free criticism but I know you *want* to be as perfect as I should like to see you—and as I don't spare myself—why should I you?

So—let yourself *go!* When you draw carefully and don't suffer from artistic constipation. I have said enough—(Pass on!).

So unforgettable were the *Stuff & Nonsense* sketches that forty years later, in 1925, Frost received the following handwritten comment in the lower margin of a formal business letter from a Boston art publisher in response to a routine subscription mail order:

> Were you the perpetrator of "Our cat takes rat poison?" If so, I should personally feel guilty in taking any money from you. I laugh now at the memory of that cat's expression as it dawned on her something was not quite right with her "tummy." And calves not flapper's, but ornery barn yard ones—I have a farm and no one put more expression in a calf's legs than A. B. Frost. I think you must be the guilty one.

A spirit of camaraderie and close lasting friendships had developed among many of the artists in New York City around late 1877. Groups met periodically in each other's studios, comparing notes, discussing their techniques and work until someone finally suggested that they formalize their meetings into a club. Frost participated in one such club, where each member would bring a tile to the meeting. A design would then be painted on the tile, which was subsequently oven fired and permanently glazed. "The Tile Club" was thus born.

The club always had something of the air of mystery about it. The meeting place was known only to its members, who numbered just twelve. The club had no officers, no dues and no expenses other than rent. Members were to bring their own tiles, cheese, tobacco and crock of cider. It is believed that each contributed to furnishing the studio meeting place, which was a quaint, comfortable "inner sanctum" with a warm fireplace and the atmosphere of the paneled library of a men's club. Each

member, upon entering the clubroom, dropped his own name and assumed a different one, probably chosen as most appropriate by the members.

Frost was known as the "Icicle;" E. A. Abbey was "Chestnut;" Frederick Dielman, the painter and one time National Academy President, was "Terrapin;" William M. Chase was "Briareus;" Augustus St. Gaudens, the "Saint;" J. Alden Weir was "Cadmium;" George Henry Boughton was the "Puritan;" F. Hopkinson Smith was "Owl;" C. S. Reinhardt was "Sirius;" among others.

The members met on Wednesday evenings, and the time was spent pleasantly in discourse on topics of the day and in general relaxation. The club location has always remained a mystery, and it is recorded that many who sought to crash a Tile Club meeting spent hours wandering around the dark alleys of the lower west side of New York City. Since telling the secret now will violate no confidences, it can be revealed that the club's headquarters were located adjacent to Abbey's studio, in a cellar alley behind an impressive wrought-iron gate at 58½ West Tenth Street.

As a monument to their existence, or probably to raise some money to pay their club rent and other disbursements, the members wrote and illustrated their own work, *A Book of the Tile Club*, which was published by Houghton, Mifflin & Co. in 1886. The book is an impressively bound deluxe edition, with phototype plates by William M. Chase, Elihu Vedder, Frank D. Millet, George W. Maynard, Arthur Quarterly, R. Swain Gifford, C. S. Reinhardt, E. A. Abbey, Napoleon Sarony, J. Alden Weir, F. Hopkinson Smith, Alfred Parsons, Frederick Dielman and W. G. Bunce.

Frost contributed twelve line-drawing vignettes, and other drawings were contributed by George H. Boughton, Stanford White, and Augustus St. Gaudens.

F. Hopkinson Smith, an author as well as artist, may have been the organizer of the book. He wrote to Frost on December 6, 1886:

My Dear Frosty:
 In cleaning out my pockets (old coat) I find a letter from you dated Nov. 10th. I don't know whether I ever answered it and I don't know whether you can read this as

I now answer it. I had a kind of an idea that you would come tumbling up my ricketies and warm your toes at my hickories, but you didn't.

And I also remember that I left word with my waitress that if a tall fine looking young man with the air of a million (millionaire) rang my tinkler, you were to be shown up into my den, and the fire punched, and a certain glass stopper taken out of an old Venetian Decanter, and a cracker provided, and the New Book laid in your lap and you to be left quietly alone—but you didn't come . . .' Tis ever thus (Byron).

All Tilers contributing to the Tile Book get the book free—the other cusses pay $12.50 (½ price). Yours will be sent to "Shocken" [Conshohocken]. But not yet—for the first edition was gotten out under such a pressure that some of the moss types are bad and so the 2nd edition is reserved for the Tilers—It will be ready about Xmas.

Meetings are going on fine,—drop in on us.—

> Thine Always
> Owl

In 1892, the "Owl" honored the Tile Club again by making it the subject of the entire second chapter of his book *American Illustrators*, published by Charles Scribner's Sons. Chapter Two, "A Night at the Tile Club," reads like the minutes of a Tile Club meeting in which the members are criticizing and discussing each other's techniques. A considerable portion deals with a Tile Club discussion of their colleague, Frost ("Icicle"). It says, in part:

The Doctor, who was always a welcome guest, and who always managed somehow to drop in during the evening, was standing with his back to the fire—a favorite attitude—holding in his hand a copy of one of the month's magazines.

"I tell you, gentlemen," he said, "for all the qualities which go to make up a caricaturist in the best sense of the word, we have no man among us who can hold a candle to your own member, A. B. Frost. Now, look at this sketch. Here are a series of drawings descriptive of a cat that has swallowed rat poison by mistake. Watch the expression in its eyes, as shown here in number one, when it discovers the character of the food. Note the wondering look on its face and the slow movement of its paw across the stomach. Only a dot and a line, and yet there is a whole volume of anxiety, alarm, misery, and fright expressed in this same dot and line—one no larger than the head of a pin, and the other no longer than its point. That is what I call genius. Now

follow the series through, and note the humor that Frost gets out of the dilated tail and glaring eyeballs in number two, and the final sketch in which the cat, having bounded under the nursery bed at last lies stretched out upon the floor, the two children above backed up against the wall, their toes doubled under them in deadly terror over the unknown cause of the domestic cyclone."

"That is because he is an American," said a Tiler. "When you come to broad humor, neither the Englishman, Frenchman, nor German—I will not even except Busch—understands its intrinsic quality so thoroughly as an American. The merit of Frost's work lies in the fact that he not only appreciates the humorous side of a situation when suggested by somebody else, but, being personally one of the funniest men alive— a perfect mine of spontaneous humor—he adds just enough of his own to make the humor of the other irresistible. You give him the slightest hint of a situation, and before you have elaborated the details he has built the scene all up in his own way into something infinitely more effective. When you add to this gift a pencil which obeys him absolutely and understandingly, it is no wonder that he gets his results."

"But you would not," said another, "consider Frost only a caricaturist. His illustrations of Ruth McEnery Stuart's 'Golden Wedding,' published in 1889, disproves that. Negro life has never been better expressed on its dramatic side. And do you remember his sketches of camp life and the drawing of the darkeys going to the dance, shuffling along the snow-covered road, half-frozen with the cold, their violins and banjos tucked under their coats? In the delineation of this line of subjects Frost is without a rival."

"I agree with you," said the Doctor. "But you have not exactly hit upon the peculiar quality of the man. What makes Frost so inimitable to me is his genuineness. This is as apparent in his work as it is in the man himself. Everything he conceives, everything he executes is based upon some positive, undeniable fact . . ."

". . . Now run over in your mind every genre painter or caricaturist you ever saw or heard of, and you will admit in five minutes that, even if you are ignorant enough to condemn Frost in his conceptions, treatment and execution, you will be forced to admit that his results are absolutely unique. He is A. B. Frost and nobody else."

With the approach of their first child, the Frosts felt the need of larger quarters. He had always harbored an inner desire for a taste of farming, and since Mrs. Frost preferred to be nearer to her family in Philadelphia, the Frosts moved to West Conshohocken, Pennsylvania, and named their new home "Prospect Hill Farm."

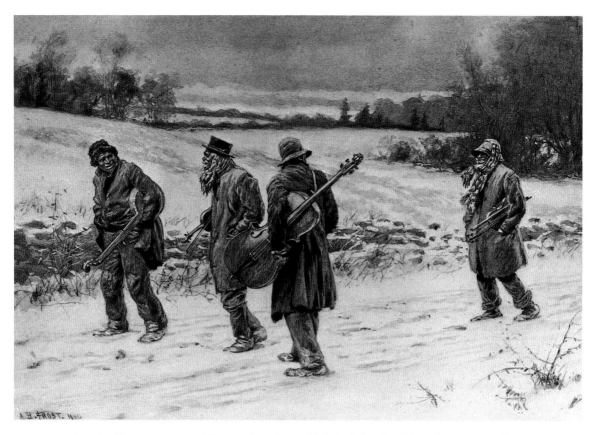

Music for the Dance, 1891. Illustration from F. Hopkins Smith's *American Illustrators,*
1892.

On December 11, 1887, their first son was born and was named Arthur B. Frost,
Jr. Having already contemplated the responsibilities of parenthood, Frost Sr. was up
to his neck in the midst of farming his little country estate in the Philadelphia suburbs
and producing a massive output of drawings for *Rudder Grange,* his first book for
Frank Stockton; *The Story of a New York House* by H. C. Bunner; and *Ogeechee
Cross-Firings* by R. Malcolm Johnson.

Frost seemed now near the height of his illustrating career. His drawings for
Stockton's *Rudder Grange* were acclaimed as his most delightful work to date and
marked the beginning of his long-time friendship with the great New Jersey author.

The Frosts spent a good portion of their summers at Beach Haven and the Atlantic
City area of New Jersey. Mrs. Frost particularly liked the shore, while Frost frequently

spent the day sailing, rowing, or hunting ducks and snipe. He did a large volume of watercolor and oil sketches in the surrounding area—beaches, dunes and the duck marshes which he enjoyed so much. In the fall, he hunted woodcock and grouse on his own farm property, with occasional hunting trips with Norris De Haven into the Swiftwater or Bushkill areas of the Poconos.

In 1889, with another child due to be born, the Frosts decided to move to larger quarters in the vicinity of Morristown, New Jersey. After a thorough search of the Morris County area, the Frosts bought a large country estate on Treadwell Avenue in Convent Station and the family moved there in the summer of 1890.

CHAPTER FIVE

Moneysunk

*T*he sixteen years that the Frost family lived in Convent Station, New Jersey, were the happiest years of their lives. For A. B. Frost, these were the years of work for which he is most remembered.

"Moneysunk" was a very appropriate name for the new Frost homestead. The main house was really a mansion—very large and stately, situated on a little hill overlooking its 120 acres and barn. The mansion had been built late in the eighteenth century on a campsite of the Continental Army by André Boisaubin, a Frenchman. The house still stands, and is a New Jersey historical point of interest. One of the large hollow columns still contains a stairway used to smuggle slaves from the attic—down the pillar stairway and into an underground tunnel which led to a barn some three hundred feet away. In the Civil War period, the house was used as a station on the underground railroad.

The old house and the country surrounding it still looks very much the same today as it did when the Frost family bought it. Old Morristowners complain that the surrounding country has been built up by developers and garden apartments, but riding through the area you can still see the large estates, horse farms, split rail and stone fences, rolling unspoiled countryside, and iron gateways reminiscent of the splendor of past years. Treadwell Avenue, where the Frost homestead was situated, is still an obscure, quaint little country road. Even the trees seem to be still in place; and one cannot help but get a feeling of nostalgia just roaming around the area where the artist worked and lived with his family.

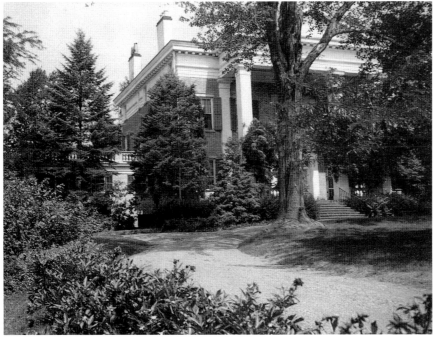

In 1890, A.B. Frost
moved his wife and
their two young
sons into this
handsome old
country house at
Convent Station,
N.J., and named it
"Moneysunk." The
next sixteen years
spent here in New
Jersey were the
most productive in
the artist's long
career.

Self Portrait, by Augustus Daggy (Frost's best friend), c. 1905, oil on canvas. Daggy Family Collection.

Frost spent most of the summer of 1890 living in "Moneysunk" alone, getting the rundown mansion ready for his family, which now included their second son, John. Apparently, major repairs were needed to get the house habitable, for his letters mention his numerous difficulties with the plumbers, painters and masons. He wrote to his friend Augustus Daggy:

> The studio is going up; the frame is nearly all up and I think I can use it by August first; I am making some changes in it which will improve it, I think. It will be like the last one, the hottest place on the farm, but I can't help that.
>
> How would you like to come rusticate with me and eat chops and raspberries? I can fit you up in a room in great shape, and will be delighted to have you.
>
> I am very sorry I could not get Anshutz's book done for him, but I have not touched a pen yet. I am out all day, going from one job to another, and am needed, I tell you; such damnable stupidity as these trained mechanics show is wonderful.
>
> Mrs. Frost and the babies are very well, and very comfortable—Good! Won't I be glad to get them here!!—

After they were finally moved in and organized in their new home, Frost plunged into the midst of a massive output of illustrations for important books. That year saw him complete a set of 146 text line drawings for *Farming* by Richard K. Munkittrick, who lived in nearby Summit, New Jersey. Next, he tackled the illustrations for a second book by his friend and close farm-neighbor, Frank Stockton, *The Squirrel Inn.*

Frost and Stockton, both of whom were strictly amateurs when it came to farming, had a constant running joke between them regarding their prowess with plow and field. If someone asked Stockton about Frost, he'd reply that Frost was one of the best fellows and best artists in the world—but no farmer. On one occasion Stockton joked, "Why, he tried to sell me what he called a first-class horse last summer, and you could hear his joints rattle when he walked. Besides, he is no judge of cows."

Frost admitted that Stockton was the best of neighbors and wrote fine stories, "but he's no farmer. He offered to sell me one of his first-class cows and I had to ask him whether a set of false teeth went with the cow before he saw that I would not buy her. Besides, Stockton is no judge of horses."

Even at this comparatively early stage in his career, Frost had long since acquired the reputation as a master draughtsman. His earliest drawings for *Out of the Hurly Burly* in 1874 were done in pen-and-ink on wood, which was then cut by the engraver so that the printing could be done right from the original wood block. This was one of the few methods of reproduction for illustrations available, and it was natural that Frost's concentration was in simple line drawings. As a matter of fact, his earliest drawings showed an economy of line, which was developed more for the benefit of the poor, eye-weary woodcut engraver than for the quality of the drawing itself. Frost's illustrations in *Almost a Man* (1877) particularly demonstrate this principle, and it is fortunate that the tedious woodcut process was superseded by other methods within the next ten to fifteen years. During this same period, the quality of his work seemed to improve in direct proportion to the improvement in the mechanical reproduction process. His line drawings in Munkittrick's *Farming* (1891) and in Joel Chandler Harris's *Uncle Remus and His Friends* (1892) point this out.

At about age twenty-five, Frost first started working with watercolors and wash

ABOVE AND FACING PAGE: Illustrations from Richard K. Munkittrick's *Farming*, 1891.

drawings in gouache, which is an opaque medium with the pigments mixed with water instead of oil. Most illustrators then working in watercolor or gouache did not use color, but worked instead in tones of black, white and gray or sepia, insofar as the reproductions were limited to black and white. Frost showed great skill in this medium and, in addition to thousands of pen-and-ink line drawings, his principal medium for illustration was gouache.

Frost was color blind, yet he was aware of color *values*. Because most of his illustrations were to be reproduced in black and white, Frost had a unique advantage—that of being able to visualize the published illustration in tones of black and white, just as the reader would. His color work rarely betrayed his color blindness. The color is never strong and garish; quite the opposite, it seems softly, timidly applied. Often it was necessary to have Mrs. Frost or one of his sons label the colors on his palette.

Some particularly fine work was done in watercolors during the period 1879–84. Perhaps it was because he was in love and romantically inclined, or perhaps it was because these particular watercolors were independent of his work in illustration, that they are so sensitive and charming. On his trips to Swiftwater and Bushkill, Pennsylvania around 1880, and to the Canadian wilderness in 1883, his watercolor sketches made directly from nature are little masterpieces of romantic charm, with colors delicately, almost timidly, applied. He was certainly dreaming of Miss Emily Phillips when he painted during this period, and it shows in his brush work.

Frost would often slip into periods of hard illustration which he later referred to as his "cast iron" period. At these times he would work and rework a drawing, always a magazine or a storybook illustration, trying to get it "just right," until it tended to lose some of the spontaneity of his better work. Always, it seemed, he would emerge

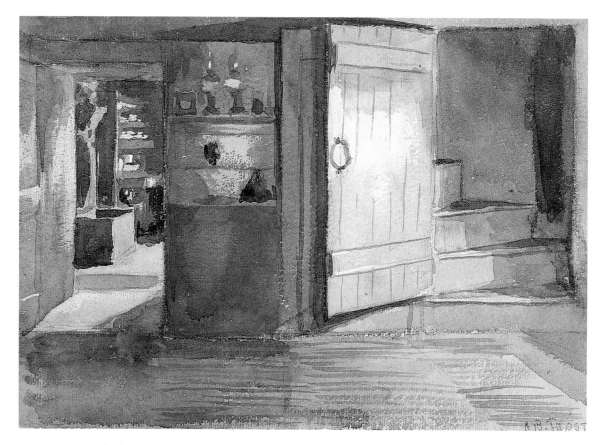

A Country Home Interior, 1879, watercolor. Private Collection.

quite miraculously from this era of hard illustration, usually after a refreshing layoff or relief from a pressing deadline.

In letters to his closest friends, he only rarely showed any satisfaction whatsoever in any phase of his painting. Usually he would fret about the "dismal rut" he was in— yet his work was getting better and better. After his initial successes on canvas, more and more work was done in this medium, including illustration in black, white, and sepia. At this stage, early in his marriage, the young artist was still struggling for financial security, so that the pressure of painting and drawing for money was prevalent.

An amusing incident, which took place one summer evening in Convent Station, tickled Frost so much he later portrayed the story. "I was trying to paint a sunset," he said, "and, having made a failure of my sketch, I scraped it off the canvas and told a

farmer who had been watching me for some time that I had not worked quick enough to get the effect. After some consideration he replied, 'Wal, why don't two or three of yez go at it at oncet [sic]'?"

By the time the family was settled in Convent and the financial pressures were at least momentarily in the background, Frost started thinking about his own true artistic ability. He also wanted his two sons to become fine painters someday, and he knew he should start them when they were still young. He also felt that he could now take a little time and study again under one of the masters. And what a choice! He became a pupil of William Merritt Chase, who was one of the most successful American impressionists and a respected teacher.

Ice Cutters, c. 1893, gouache. Achenbach Foundation for Graphic Arts. The Fine Arts Museums of San Francisco. Gift of Mr. and Mrs. John D. Rockefeller III.

Bicycling in the Snow, 1898, gouache.
Private Collection.

Frost wrote to Daggy, early in 1891:

I have started painting with Chase and I think he will do me a power of good. He will get me to loosen up my blamed tight fist, and get some go into my work. I feel sure he can do me a great deal of good. I like Chase, both personally and artistically, his last summer's landscapes, painted in Central Park, are beautiful. No "purple fad" business, but full of air and out-of-doors.

About a month later, he wrote Daggy again:

I am going to Chase every Tuesday and Chase really seems to like what I do. He told me last Tuesday that I was *painting.* He said "that is painting that is not straining." I have a great respect for his knowledge. He certainly knows a lot that a painter ought to know. He started a picture of Carmencita today, or expected to. It is a commission,

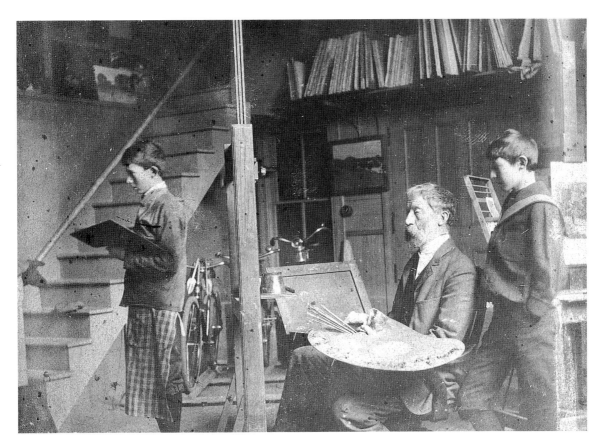

A.B. Frost and his two sons in the studio at Moneysunk, c. 1903. A.B. Frost wanted his two sons to become painters and started teaching them when they were young.

and I think he will make a good thing of it. He is right in the humour for it and so is Carmencita. She is to dance at his studio on Monday evening, and I am going in to see her; quite a swell affair, given by some Nabob in New York, Chase asked me. He has a splendid portrait of Whitredge. One of the best heads I ever saw; fine and strong and good color.

I hear the Water Color is very good, and that Smedley is particularly good. I haven't seen it yet. The Academy in Philadelphia is strong, too, has that fine portrait of Sargent's of the Mother and boy.

I am, as usual, driven wild by my work. I am doing Broadway for Scribner's and in a devil of a hurry. I never seem to get time to do decent work, always in a rush. This is the last article on hand, and I mean to make it the last for some time. I have a lot of schemes and mean to try to carry some of them out, painting a little now and then.

The Blue Bowl, 1891, oil on canvas. Private Collection.

Again to Daggy on February 19, 1891, he wrote:

I went to the Water Color Annual Supper on Saturday night and had a very good time, saw all "the boys" and enjoyed it. Bob Ingersol made a bully speech all about Art. He knows less about art than he does about Hell, but he made a mighty good speech all the same; it is a great thing, that gift of "the gab," when a man can talk entertainingly for 20 minutes about something he doesn't know anything about—what must he do when he is on a theme he does know something about . . .

Later in the same letter, in an obvious reference to "still life" painting of the usual pots and vases on table tops under instruction from his teacher, William M. Chase, he

wrote: "I am becoming quite the pot painter. I paint pots and pans at Chase's 'til you can't rest."

Under Chase's tutelage Frost improved greatly. His canvases lost the tell-tale minute detail trade-mark of the illustrator and developed a free-flowing style and a keen perception toward tasteful composition. Although Frost would have been the very last artist in the world to consider himself impressionistic in any way, his oil landscapes give one the feeling of exuberant freedom from the hard confines of illustration. He chose surprising numbers of still-life subject matter to paint, and his canvases give the impression that he was enjoying his work tremendously.

Nevertheless, Frost still had a tremendous backlog of illustration ahead of him, and his most important work in this field was still to come before he could give it up to become a painter.

CHAPTER SIX

Brer Rabbit and Uncle Remus

During his career as an American book illustrator, nothing by A. B. Frost exceeded the popularity of his illustrations for the Uncle Remus tales written by Joel Chandler Harris. Some observers, including Harris himself, have attributed the success of the books to Frost's drawings as much as to the stories themselves. In an 1895 letter to Harris, in the Robert W. Woodruff Library at Emory University, Rudyard Kipling wrote: "What a splendid job Frost has made of the pictures . . . they will march down the ages as the original and sealed pattern of Brer Rabbit and the others . . ."

The first meeting between Joel Chandler Harris and A. B. Frost occurred in 1886, while Frost was in Georgia doing a series of illustrations of Southern scenes for *Century* magazine. Frost had already illustrated Harris's *Free Joe and the Rest of the World* two years before. After an inauspicious beginning, since both men were ill at ease with strangers, the great southern editor finally warmed up to the northerner who was to become the illustrator for nearly all of his important books which followed.

Together, the two made a trip into northern Georgia. Frost carried a sketchbook, and created twenty-nine pages of drawings, mostly of country scenes, a cotton gin and a portrait sketch of Harris. Two simple watercolor landscapes have survived.

The following year, Frost made illustrations for Harris's "Little Compton," in *Century* magazine, and the frontispiece illustration for Harris's *Free Joe and Other Georgian Sketches.* Once begun in 1892, Joel Chandler Harris's books with Frost's illustrations followed in rapid succession:

Sketch of Joel Chandler Harris, 1886, pencil on paper. Special Collections Department, Robert W. Woodruff Library, Emory University.

1892 *Uncle Remus and His Friends.* Boston: Houghton, Mifflin and Co.

1895 *Uncle Remus, His Songs and His Sayings.* New York: D. Appleton and Company.

1899 *The Chronicles of Aunt Minervy Ann.* New York: Charles Scribner's Sons.

1904 *The Tar Baby and Other Rhymes of Uncle Remus.* New York: D. Appleton and Company.

1905 *Told by Uncle Remus: New Stories of the Old Plantation.* New York: McClure, Philips & Company.

1918 *Uncle Remus Returns.* Boston: Houghton, Mifflin and Company.

c. 1935 *The Uncle Remus Book.* Retold by M. B. Huber. New York: Appleton-Century.

Is there any body of illustration in American literature which surpasses Frost's illustrations for Joel Chandler Harris's Uncle Remus books? Howard Pyle's colorful pirates and knights in shining armor immediately come to mind, as well as N. C. Wyeth's patriotic, red-blooded Americans, but it must be agreed that Harris's Uncle Remus tales with Frost's illustrations have taken their place among the classics of American literature.

One of the best ways to understand this famous collaboration is to quote a portion of the letter from Harris to Frost, written May 30, 1892:

> I enjoy your work whether it is humorous or serious, and the Cow and the painter in *Scribner's* came near putting me to bed. I laughed till I was as sore as an amateur baseball club in the suburbs. I want you to illustrate the matter *in your own way*,

Landscape in Georgia, 1886, watercolor. Private Collection.

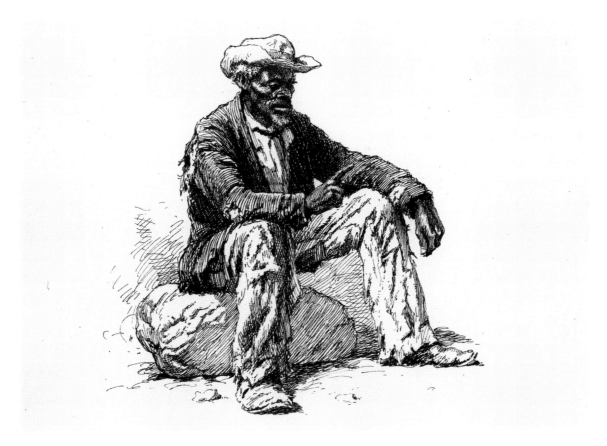

Illustration for Joel Chandler Harris's *Free Joe and the Rest of the World.*
Century, November, 1884.

which is preeminently the American way. We shall then have real American stuff illustrated in real American style. Be as comic as you choose, or as commonplace as you choose—you can't possibly fail to please me. There's this consolation: If you can't find fun in *my* stuff, you've got it in your bones, and fun is what we're after. Thank heaven! We're both red-headed.

Such criticism from an author to his illustrator must have been inspiring. What further inducement would an illustrator need to encourage him to produce his best work? Frost was usually the most rambunctious, irascible and self-deprecating of artists. With the "animal tales," as Frost described them, he was actually pleased with the results and enjoyed making the drawings. On October 1, 1892, he wrote to his lifelong friend Augustus Daggy:

I am doing a book for Uncle Remus, and am not getting ahead very fast with it, but I am making good drawings, which is better. I wish you could see them before they go in. I think they are about the right thing for the subject. I enjoy making them very much.

In another letter dated April 10, 1893, Frost wrote to Harris:

I never enjoyed any work so much, in spite of the fact that I was very much hurried and had to have the drawings done at a certain date and to deliver them in small batches; I enjoyed it thoroughly; I worked over them as late as I could every day clear up to dark most of the time, and I did them very quickly, Of course I was hampered in the selection of subjects. One is always in illustrating a book. You have to lay out the pictures so that they will come out in certain pages and not too close together, and you are forced to pass over the very best point very often. I wish I could do it all over again and make twice as many drawings.

What a difference from the humiliating criticism Frost had received from the Rev. C. L. Dodgson a little more than a decade before, when he was making the drawings for the famous English author's *Rhyme? And Reason?*.

The first Uncle Remus book contained three full-page wash drawings and nine pen-and-ink line drawings. If Harris felt the illustrations were "too few by a couple dozen," he certainly saw to it that this situation was soon corrected. Shortly after his first Frost-illustrated Uncle Remus appeared, the decision was made to publish a new and revised edition of the original *Uncle Remus, His Songs and His Sayings*, which had first appeared in 1880, with drawings by Frederick S. Church and James H. Moser. Published in 1895, this new edition was illustrated with 112 A. B. Frost drawings. The preface and dedication contains the open letter by the author to Frost which states, in part:

. . . it would be no mystery at all if this edition were to be more popular than the old one. Because, by a stroke here and a touch there, you have conveyed into their quaint antics the illumination of your own inimitable humor. . . . The book was mine, but now you have made it yours, both sap and pith.

Uncle Remus Telling Tales, gouache, 1895. Drawing for frontispiece
of Joel Chandler Harris's *Uncle Remus, His Songs and His Sayings*.
Private Collection.

In a review of Frost's Uncle Remus drawings on exhibition at Frederick Keppel Gallery, the New York *Tribune* wrote on November 17, 1895:

> . . . Mr. Frost's sketches for the new edition of "Uncle Remus." They are delicious. No other word will do. Technically they exhibit the fine maturity of Mr. Frost's art, his tact in the handling of line, his fineness in matters of color, his skill in making his pen as eloquent as a brush and in giving to black and white designs the solidity and the variety of paintings in oil . . . But technique is soon forgotten in the contemplation of these drawings. They are fun incarnate . . . Their costumes are irresistible. Their attitudes are indescribable—But the only thing to be said of the work as a whole is that it is screamingly funny, the most brilliant piece of humorous characterization which has been done in the history of American art.

From the New York Evening *Post*:

> . . . One goes about the gallery smiling, or talking to total strangers about the drawings and the tales they illustrate. Certainly a kinship exists between Mr. Harris and Mr. Frost to a delightfully sympathetic degree . . . One departs from the exhibition inwardly wondering who is the more fortunate, Mr. Harris in having his inimitable work so perfectly interpreted, or Mr. Frost in having so joyous a theme to celebrate.

Together, the editors of the *Tribune* and the Evening *Post* said it all. Harris and Frost had created one of the greatest, most unforgettable classics of American literature.

As happens so often, the first sketches by an artist, the initial products of his mental formulation, provide a privileged glimpse right into his soul. These initial drawings or sketches can sometimes be very slight, and seem to lack significance, yet often possess a spontaneity and freshness which can rarely be recaptured.

Many years ago this author was fortunate to receive A. B. Frost's personal copy of an early edition (1893) of *Uncle Remus, His Songs and His Sayings*, illustrated by Frederick S. Church and James H. Moser. It is a very well-worn, dog-eared copy, with soiled backstrip, loose binding, and the contents intact but shaken. Throughout the pages, there are numerous pencilled annotations in Frost's handwriting, entire paragraphs marked with the word "done," and dozens of spontaneous little sketches done in the margins, or sometimes drawn right over the printed text.

Frost had used this very book, had read it with pencil in hand, planned the illustrations, making tiny drawings from that wondrous mental process which instantly connected his eyes and his brain with the hand and fingers which so deftly directed his pencil. What a treasure!

I have sat for hours with this book in my lap, slowly turning the pages, revelling in the nostalgic atmosphere of days nearly a century ago, visualizing the artist, pencil in hand, with this very same book in *his* lap, making these priceless little sketches. I am, I realize, a sentimentalist, but to hold this book and to imagine Frost sitting in the house which I know well, making these drawings, is a moving experience.

After having owned the book for just a year or two, I began to realize it should go somewhere else, surely to that great southern university library in Atlanta where it could be cared for and exhibited as part of their Joel Chandler Harris Collection. In 1978, it was given to Emory University's Robert W. Woodruff Library and has been shared with the public from that time on.

It has always been my hope that some way could be found to share it with the larger public—those far removed from Atlanta, but Frost's pencil sketches, although visible, are slight, and have faded to a shade lighter than the printed text on the pages. Another problem is that only one page can be seen at a time.

Arrangements were made to conduct some experimental photography with an Emory University professor, Dr. Thomas H. English, now a much admired, close personal friend.

The results are shown on these pages. When viewed in context with Frost's final, published versions of them, the sketches begin to take on real significance. The artist's finished versions vary little from his original vision as he read the text. So, a small selection are offered here in the hope that the reader can somehow overlook the inability of the photographic process to adequately recapture the essence of the original sketches, and yet, in some way, recreate the atmosphere surrounding the creation of these great illustrations.

Aside from a dozen pencil sketches and studies, none of the completed illustrations from the Uncle Remus tales remained in the artist's estate when Frost died in 1928.

Rabbit,' sez she, 'I reckin may be I kin fetch my hawn out,' sez she. Den Brer Rabbit, he come up little closer, but he ain't gittin' too c

"'I speck I'm nig sezee. 'I'm a mighty p sezee. 'You do de pul gruntin',' sezee.

Den Miss Cow, she atter Brer Rabbit, en Rabbit wid his years la down en 'er tail curl. bimeby he dart in a b come 'long he had his head stickin' out, en his eyes look big ez Miss Sally's chany sassers.

"'Heyo, Sis Cow! Whar you gwine?' sez Brer Rabbit, sezee.

"'Howdy, Brer Big-Eyes,' sez Miss Cow, sez she. 'Is you seed Brer Rabbit go by?'

"'He des dis minit pass,' sez Brer Rabbit, sezee, 'en he look mighty sick,' sezee.

"En wid dat, Miss Cow tuck down de road like de dogs wuz atter 'er, en Brer Rabbit, he des lay down dar in de brier-patch en roll en laff twel his sides hurtid 'im. He bleedzd ter laff. Fox atter 'im, Buzzard atter 'im, en Cow atter 'im, en dey ain't kotch 'im yit."

A.B. Frost's preliminary sketches for Joel Chandler Harris's *Uncle Remus, His Songs and His Sayings,* as made in the 1893 edition. Insets show his final illustrations published in the 1895 edition.

One en all on us knows who's a pullin' at de bits
 Like de lead-mule dat g'ides by de
En yit, somehow er nudder, de bestes
 Mighty sick er de tuggin' at de cha

Hump yo'se'f ter de load en fergit de
 En dem w'at stan's by ter scoff,
Fer de harder de pullin', de longer de
 En de bigger de feed in de troff.

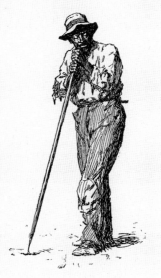

ter cum fum, an' I feel a little ache sorter crawlin' long on
my jaw-bone, kinder feelin' his way. But de ache don't
stay long. He sorter hankered 'roun' like, en den crope
back whar he come fum. Bimeby I feel 'im comin' agin,
an' dis time hit look like he come up closer—kinder skum-
mishin' 'roun' fer ter see how de lan' lay. Den he went off.
Present'y I feel 'im comin', an' dis time hit look like he kyar'd
de news unto Mary, fer hit feel like der wuz anudder wun
wid 'im. Dey crep' up an' crep 'roun', an' den dey crope off.
Bimeby dey come back, an' dis time dey come like dey
wuzen't 'fear'd er de sroundin's, fer dey trot right up unto
de toof, sorter zamine it like, an' den trot all roun' it, like
deze yer circuous hosses. I sot dar mighty ca'm, but I
spected dat sump'n' wuz gwine ter happ'n."

"And it happened, did it?" asked some one in the
group surrounding the old man.

"Boss, don't you fergit it," responded Uncle Remus,
fervidly. "W'en dem aches gallop back dey galloped fer
ter stay, an' dey wuz so mixed up dat I couldn't tell one
fum de udder. All night long dey racked
an' w'en dey got tired er rackin' an' gallo
in on de ole toof an' thumped it an' go
'peared unto me dat dey had got de jaw-
an' wuz tryin' fer ter fetch it up thoo d
an' out at der back er my neck: An' dey
Mars John, he seed I wuz 'stracted, an'
go roun' yere an' git sump'n' put on it, an
'lowed dat I better have 'er draw'd, an'
more'n cole 'fo' wunner deze yer watch

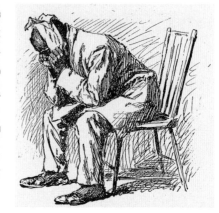

dogs a howlin' an' squinch-owls havin' de ager out in de
woods, an' w'en a bull goes a bellerin
bones git cole an' my flesh commenc
w'en it comes ter deze yer sines in de
rits in de woods, den I'm out—den
fack. I bin livin' yer more'n sevent
er niggers seein' ghos'es all times er
day, but I ain't never seed none yit ;
Jacob's lathers, I ain't seed dem, n

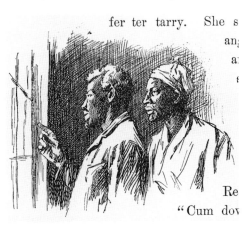

"Dey er dar, Brer Remus."

"Hit's des like I tell you, Bre
'bout it, but I ain't seed um, an' I
deze days on dat w'at I don't see, an
ter 'zamine mighty close. Lemme
don't you let deze sines onsettle you. W'en old man Ga-
brile toot his ho'n, he ain't gwinter hang no sine out in de
winder-panes, an' when ole Fadder Jacob lets down dat
lather er his'n you'll be mighty ap' fer ter hear de racket.
An' don't you bodder wid jedgment-day. Jedgment-day
is lierbul fer ter take keer un itse'f."

"Dat's so, Brer Remus."

"Hit's bleedzed ter be so, Brer Ab. Hit don't bodder
me. Hit's done got so now dat w'en I gotter pone er
bread, an' a rasher er bacon, an' nuff grease fer ter make
gravy, I ain't keerin' much w'edder fokes sees ghos'es er
no."

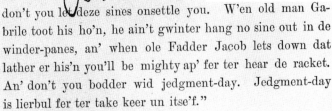

Unpublished drawing,
pen and ink, 1918.
Private Collection.

The original drawings for the published illustrations seem to have scattered. Emory University's Joel Chandler Harris Collection has woefully few. A few others are in the New York Public Library and The Library of Congress; two are in The New Jersey Historical Society; The Sterling and Francine Clark Art Institute in Williamstown, Massachusetts, has a fine Brer Rabbit watercolor; and some have made their way into private collections; but dozens remain to be accounted for. Where, for example, is Frost's immortal wash drawing of Brer Rabbit stuck to the Tar Baby? I have been fortunate enough to find a few of them, some of which are illustrated on these pages. The search for these drawings has become a passion for me.

An amusing, but tense, incident took place many years ago in my search. The scene was an afternoon sale of American paintings and drawings at Sotheby's. The catalog listed two drawings by Frost in a single lot. The first was a baseball drawing, signed;

the second drawing was listed simply as "a Tiger," unsigned. The drawings were not illustrated in the catalog.

The instant I saw "a Tiger" at the auction preview, I recognized Brer Tiger from *Uncle Remus and His Friends*, the first Frost-illustrated Uncle Remus book, published in 1892. The drawing was an unfinished one, discarded by the artist; it had been spoiled by an accidental blot of the black ink just under the Tiger's right knee. Nevertheless, it was of great interest to me. The gallery's estimate was a reasonable $800-$1,000 for both drawings together. My plan was simple; buy them both, keep the Tiger, and reconsign the baseball drawing for a future sale.

I failed miserably. The lot opened around $300 with several bidders. When the bidding reached the $600 level there were only two of us, with my opponent bidding by telephone. Up and up it went, over $1,000, my hand still raised and confident,

LEFT: *Br'er Tiger*, 1891, pen and ink. This discarded drawing was spoiled by an ink blot above the right foot. RIGHT: published illustration from Joel Chandler Harris's *Uncle Remus and His Friends*, 1892.

Br'er Ba'r, Br'er Rabbit and the Honey Bees, pen and ink.
Private Collection.

F 392

Br'er Rabbit, watercolor over pencil sketch. Sterling and Francine Clark Art Institute.

but he wouldn't quit! "Who is he?" I asked myself, "the Baseball Hall of Fame in Cooperstown?" Now it was over $2,000 and my heart was pounding. "This is an original Uncle Remus drawing," I kept telling myself, "don't give up!" At last the telephone bidder said "$2,500" and I had to stop, devastated.

I left the gallery totally beaten and very downcast. I kept wondering about the identity of the other bidder, and when I reached my office in New Jersey, I had an idea. Suppose my opponent had been bidding only on the baseball drawing, while I was bidding only on the Tiger, and we had been running each other up? I called Sotheby's and explained my problem. They were very cooperative and hopped right on it. My theory was correct, as it turned out, and my opponent was a real gentleman, an attorney from the midwest. We found a way to divide the cost; he got his baseball drawing and I got my Tiger!

The wide dispersion of the original published Uncle Remus drawings is probably attributable to a single event, the only thing which casts an unfortunate pallor on this most joyous of collaborations. On December 11, 1927, Frost wrote to Margaret Jemison, an Emory University librarian:

> I would be glad to send a drawing from "Uncle Remus" if I had one, but, unfortunately, I did not keep them. I neglected to contract for the drawings to be returned to me and Appleton's exhibited them at the Keppel Gallery and sold them for *more* than they paid me for making them, thereby getting their book illustrations for nothing and making money besides. It was the most unfortunate business deal I ever made.

Even this cannot tarnish the joyous partnership of the author and his illustrator. In January, 1895, Joel Chandler Harris wrote a poem which summed it up beautifully:

> I'll tell you de trufe Miss Adelaide
> Which I speck I ought not ter do
> Marse Frost done gone en lay me in de shade
> So bad I dunner what ter do.
> I wuz skeered fer ter say it right out in de book
> But now it's what I'll stick ter
> I never did know how de creeter look
> Twel Marse Frost tuck der pictur.

The Sporting Pictures

Overshadowing almost all of his other works, collectively—including even the Uncle Remus illustrations—A. B. Frost is most remembered today for his hunting and shooting scenes, particularly those of men with guns and dogs.

Great masters such as Winslow Homer, George Inness, Albert Bierstadt, and even our greatest portraitist, Thomas Eakins, all created important examples of sporting art. Arthur F. Tait, the great Adirondack and western painter of the latter part of the last century, was one of our earliest notable sporting artists. Fanny Palmer, who shared Currier & Ives fame along with A. F. Tait a century ago, is our most famous woman sporting artist. Her quaint, colorful woodland scenes of well-dressed gentlemen with six-foot-long shotguns and ill-proportioned dogs fill hundreds of curly maple frames in the old print shops and homes of antique collectors in this country and abroad.

Other outstanding sporting artists include Frank W. Benson, Roy M. Mason, A. Lassell Ripley, Roland Clark, Ralph Boyer, Edwin Megargee, Marguerite Kirmse, Lynn Bogue Hunt, Eric Sloane, and Odgen M. Pleissner, whose pictures are found in the finest collections and museums.

While many artists may have surpassed A. B. Frost in technique, handling of color, and other aspects of artistic merit, Frost is regarded by many as the finest of them all. A sportsman himself, Frost was able to vividly portray the feelings and experience of hunting in his imagery. The appeal of Frost's shooting pictures lies in the fact that the viewer can relate to the subject and the situation depicted. Every scene portrayed is

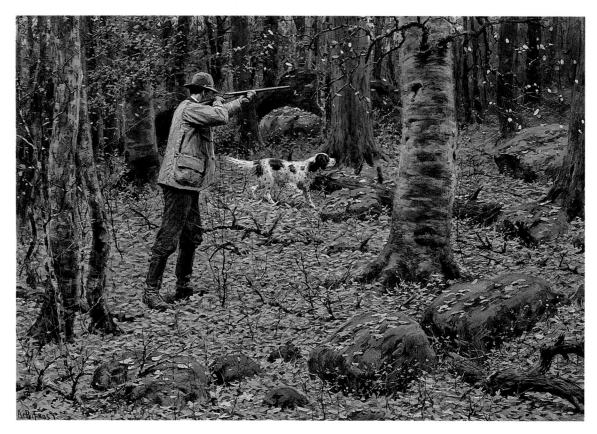

Grouse Shooting, c. 1895, gouache. Private Collection.

one that each of us who has hunted with dog and gun has experienced—the setter staunchly on point, the gun ready, thumb on the safety, and heart pounding as we await the explosive fluttering of wings as the bird flushes. Or the duck hunter, hands numb and nearly frozen, crouching low in his blind as the flight of ducks suspiciously circles lower toward his decoys. Even the cursed humor of the missed shot, the gun-shy dog retreating at top speed, or the tight cartridge that won't eject—all of these are situations which the artist handles with such realism and familiarity that the viewer is placed squarely in the center of the adventure. The hunter's clothing is just right, even to the bulge in his gamepocket. The pointing dogs are magnificent—sneaky, noses moist and low, and their weightless balance, with forefoot raised, is perfection. The landscape backgrounds for the shooting pictures signify autumn, with grey morning

mist behind the birches, the fallen leaves wet with morning dew. The open fields, with russet-colored weeds and stubble, seem to be perfect hiding places for pheasants or quail in their hedgerows.

One grouse shooting scene is particularly noteworthy. The setting is deep in a forest interior, the ground totally covered with new fallen leaves, boulders and a few dead limbs protruding from the forest floor. The hunter, in the midst of a stand of beeches and hardwood trees, is taking aim at a grouse. His weight is forward on his left foot, his slouch hat, wrinkled canvas jacket, and leather boots are meticulous, down to the metal buckle. The English setter is sublime, still holding his three-legged point, tail straight and extended—a masterful drawing, all done in tones of black, white and sepia.

For many years, Frost's hunting scenes appeared in *Scribner's* magazine, and quite often as a centerfold spread in *Harper's*. Charles Scribner, from nearby Morristown, was a friend and neighbor of Frost, and this relationship undoubtedly contributed to the decision by Charles Scribner's Sons to publish Frost's *Shooting Pictures* portfolio of 1895.

The *Shooting Pictures* portfolio, consisting of twelve color lithographs, immediately gave Frost his position as our premier sporting artist. Yet Frost himself, in typical fashion, could not be pleased. He wrote to Daggy on December 2, 1895:

> I have not got these damned shooting things done yet. They drag, and are a mill stone "round my neck," and the reproductions are enough to make a dog sick...

Frost wrote to Daggy again in February, 1896.

> We have had a tough time since Christmas. The boys were taken sick the same day soon after Christmas, influenza. Then Mrs. Frost got it. About the time the boys got well I went down and was sick just a month, in bed over a week, and am only now feeling like myself again. We were pretty blue too, for I worked on those shooting pictures all the Fall, and got no money and we got behind hand; and it wasn't pleasant. We are better off now for I am working again and there is "mon" coming in.

The *Shooting Pictures* depicted the most popular forms of upland game and shorebird hunting of the times. Contained in a large board portfolio decorated with red imitation leather, red ribbon tie strings, and with a Frost-drawn English setter's head on the cover, the lithographs were divided into six parts of two plates each, contained in heavy grey paper wrappers. A large text sheet written by Charles D. Lanier came with each color plate, describing each kind of shooting. Frost illustrated each text sheet with three pen-and-ink vignettes.

Over the years, the favorite prints were removed from the portfolios and framed, and the remainder of the clumsy wrappers and tissue sheets discarded. Today it is difficult enough for collectors to accumulate the twelve color plates, but nearly impossible to find the original board portfolio with the fragile wrappers and text sheets.

A facsimile set of the portfolio was published later by the Winchester Press. No effort was made to counterfeit the original; the portfolio is intentionally smaller than the 1895 version. The prints themselves are of high quality, and printed with margins, to distinguish them from the 1895 prints, which had none. The original *Scribner's* prints measured 13 by 20 inches without margins, except for the *Bay Snipe Shooting* print which measured 12½ by 20 inches.

Some years later, another of the Frost *Shooting Pictures* was reproduced. This print, *Quail—A Covey Rise* was printed by R. R. Donnelley & Sons Company. Like the Winchester Press edition, it was also of high quality, and slightly reduced in size, with margins.

The following are the titles of the twelve shooting pictures which were chromolithographed in the *Scribner's* portfolio:

Autumn Woodcock Shooting	*Prairie Chickens Shooting*
Autumn Grouse Shooting	*English Snipe Shooting*
Quail—A Dead Stand	*Ducks from A Blind*
Quail—A Covey Rise	*Ducks from A Battery*
Rabbit Shooting	*Bay Snipe Shooting*
Summer Woodcock	*Rail Shooting*

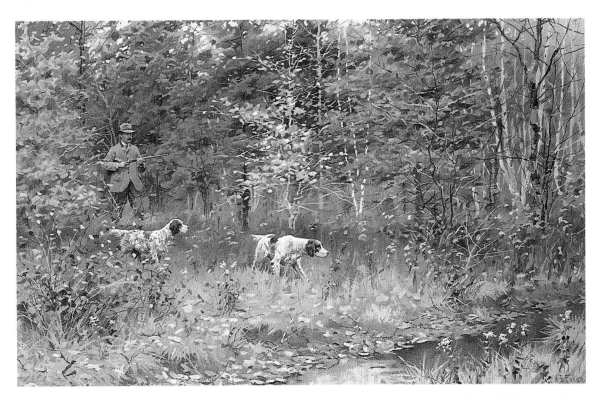

Autumn Woodcock Shooting, from the *Shooting Pictures,* 1895, portfolio of lithographs.

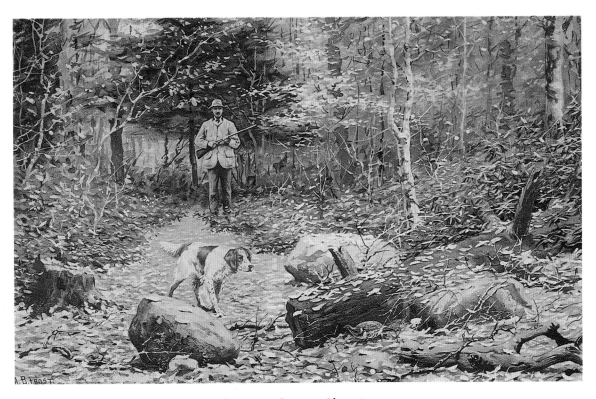

Autumn Grouse Shooting

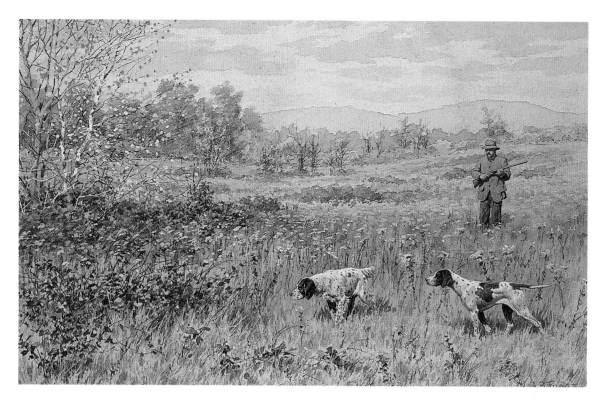

Quail—A Dead Stand

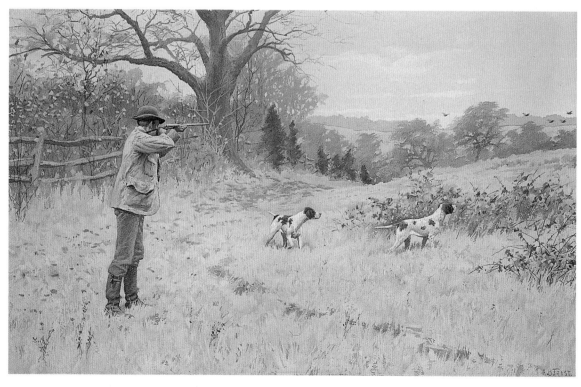

Quail—A Covey Rise

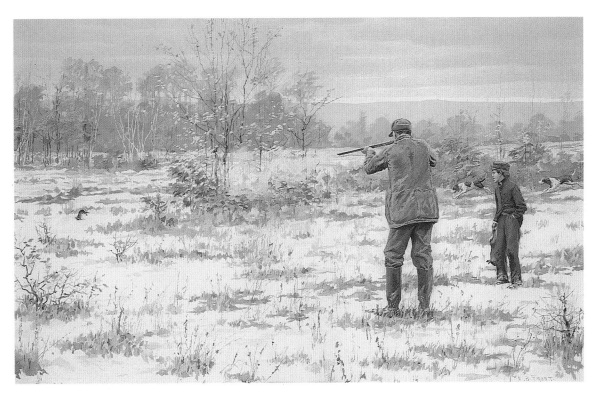

Rabbit Shooting

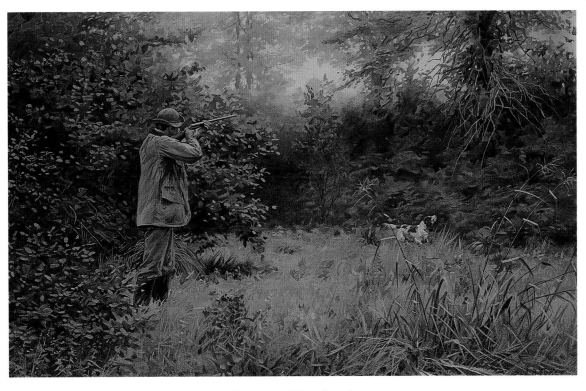

Summer Woodcock

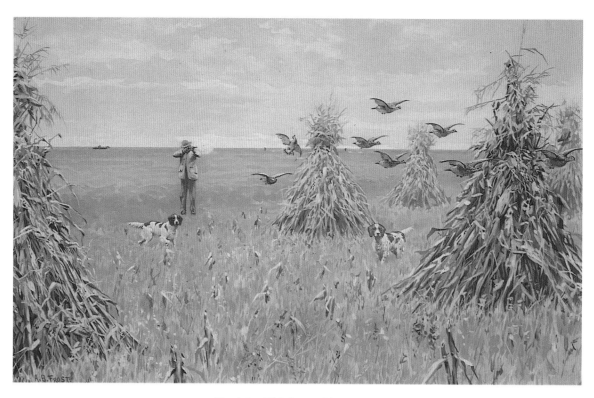

Prairie Chickens Shooting

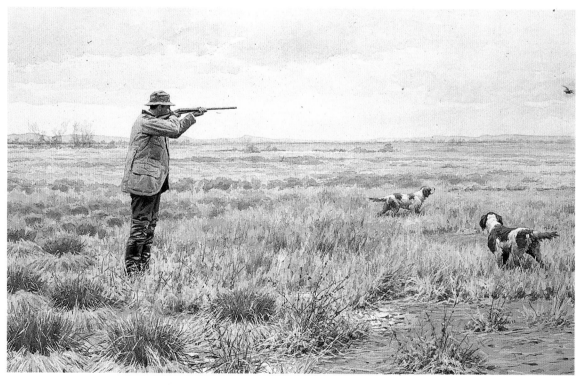

English Snipe Shooting

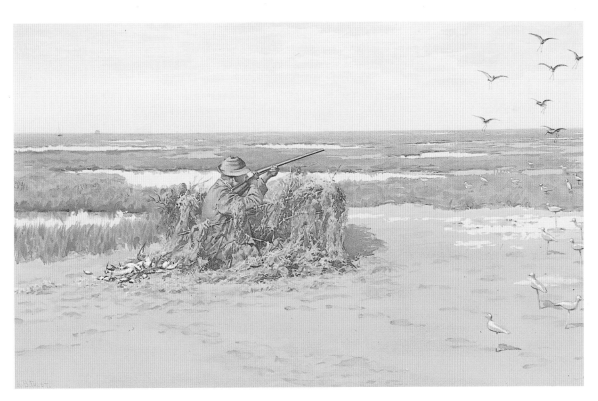

Bay Snipe Shooting

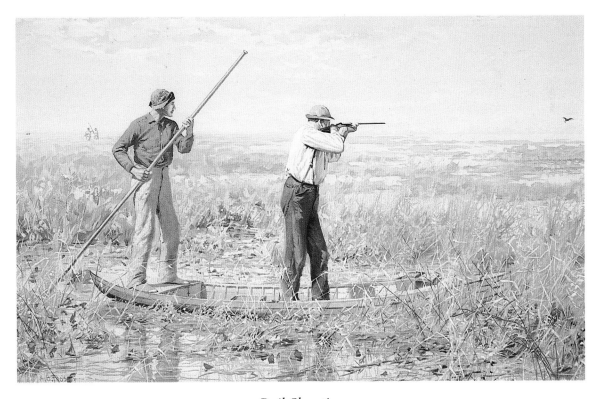

Rail Shooting

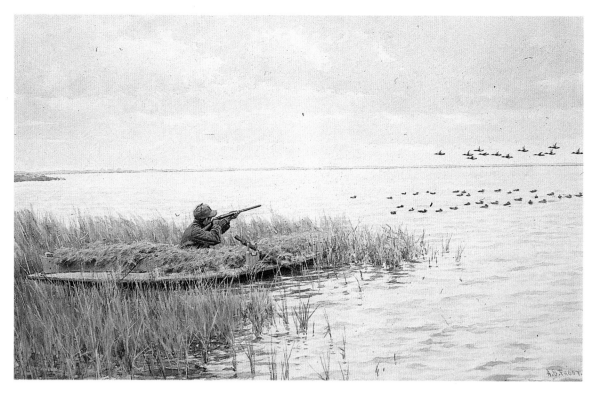

Ducks from A Blind

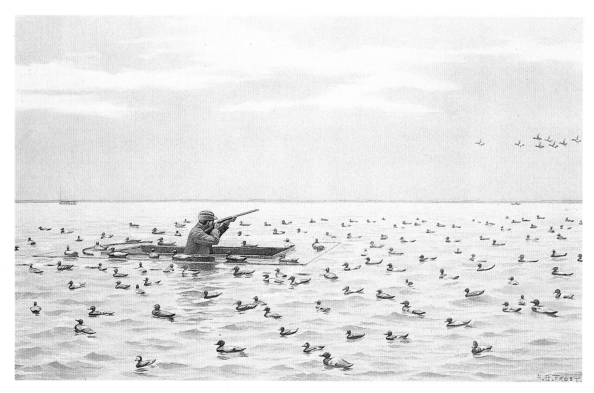

Ducks from A Battery

In 1903, Scribner's produced another set of A. B. Frost shooting pictures, entitled *The Day's Shooting*. This portfolio consists of six chromolithographs, attractively packaged in a colorful flat box, imprinted with the title and a scene of the hunter and his dog starting out eagerly for "The Day's Shooting." On the bottom of the box the hunter and his dog are shown again, trudging homeward after a hard day's hunt.

Each of the plates is mounted by the upper corners on a grey cardboard backing. Two of the plates are horizontal, and four are vertical. Printed without margins, their size is 16 by 11 inches, or 11 × 16 inches, depending on whether the print is seen upright or horizontally. The titles are imprinted in very small letters on the bottom center of each print. They are:

Ordered Off *Bad Luck*
Gun Shy *Smoking Him Out*
Good Luck *We've Got Him*

This set of six prints is almost as difficult to assemble as is the entire 1895 Scribner's set of twelve *Shooting Pictures*. In *The Day's Shooting* portfolio, Frost displayed his sense of humor and his *human* qualities as an artist. The situations are familiar to all hunters. Success and failure received equal billing. Over the years I have seen three of the six prints in their original watercolor state; not all are in the same collection.

The Derrydale Press brought out another set of prints, published posthumously in 1933-34. The titles are:

October Woodcock Shooting
Grouse Shooting in the Rhododendrons
A Chance Shot While Setting Out Decoys
Coming Ashore

Skillfully photolithographed on the finest rag paper, and hand-colored with wide margins and engraved titles, the edition was to consist of 250 copies of each subject. John Frost, the artist's son, and a skilled artist himself, hand-colored the first copies

Starting Out, 1903, original watercolor for the top illustration of *A Day's Shooting*, portfolio of six lithographs. Courtesy of The Morristown Club.

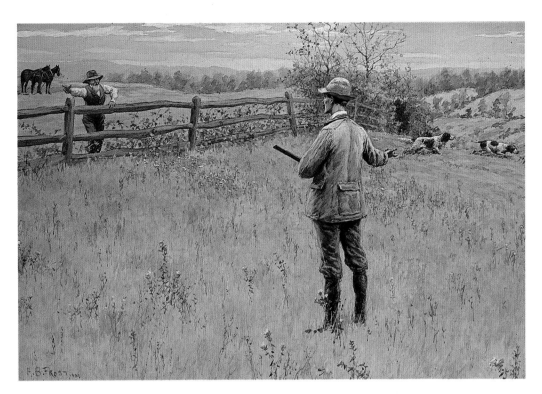

Ordered Off

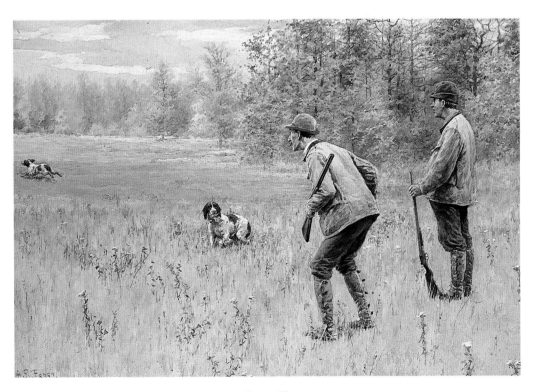

Gun Shy

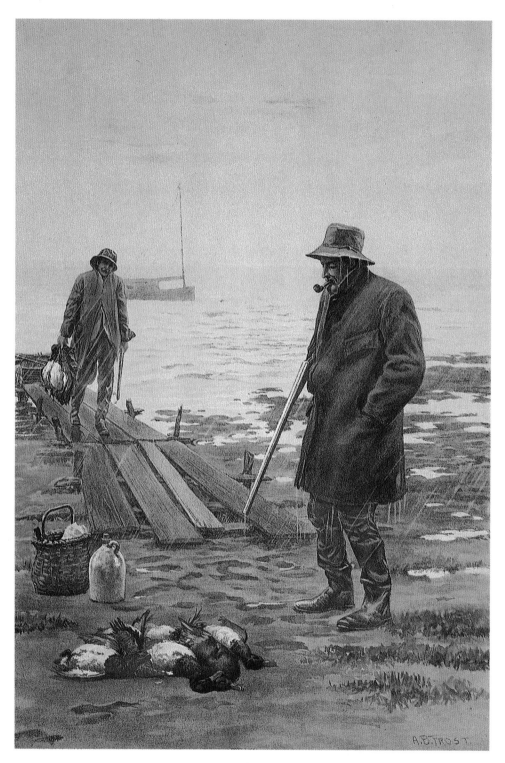

Good Luck

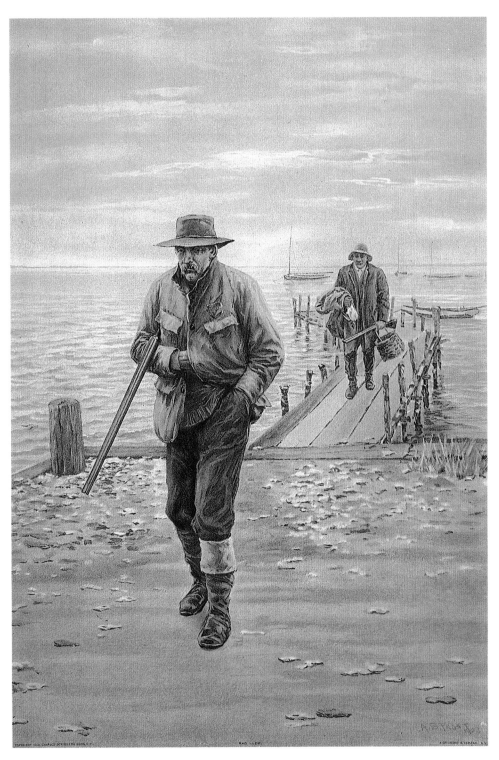

Bad Luck

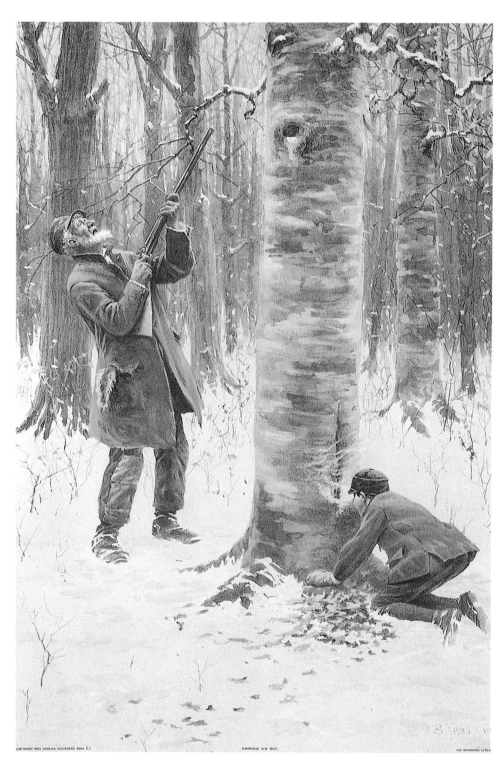

Smoking Him Out

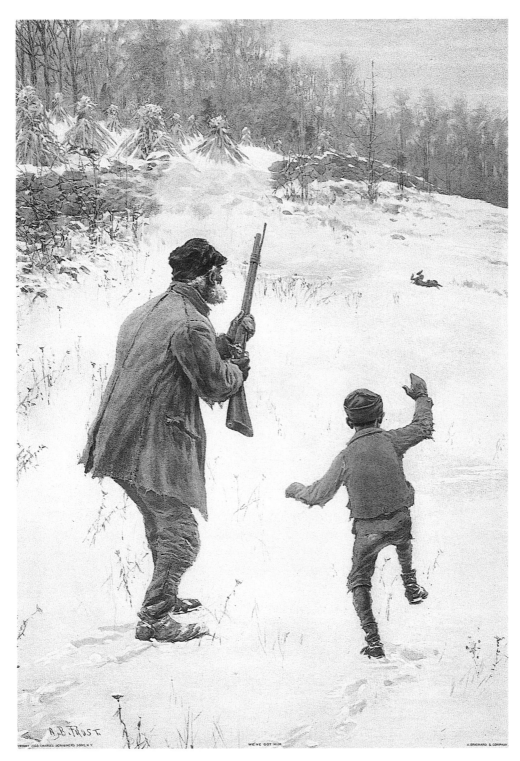

We've Got Him

Returning Home, 1903, original watercolor for the bottom illustration of *A Day's Shooting* portfolio. Private Collection.

off the press as a model for the coloring artists. It is believed that somewhat fewer than 200 of each print were finished and hand-colored. This accounts for the fact that these prints are the rarest of all the A. B. Frost shooting prints.

Although Frost's depictions of big game hunting contain all the elements of suspense, anticipation, and accuracy as his small game shooting pictures, deer hunting was not to his liking. We know of only one deer hunting incident in which he was involved, and it left him ashamed and disgusted. He described it in a letter to his fiancée, from Long Lake, Canada, on August 25th, 1882, as reported by Henry Wysham Lanier in *A. B. Frost, The American Sportman's Artist* (New York: Derrydale), 1933:

> Well, I've killed a deer, and I'm not proud of it. Not being a butcher I am not elated over the affair. As Joe was completely out of venison, he made an effort yesterday, and we succeeded in slaying a deer.
>
> He came down from the perch he had been watching from and we got into the canoe, and he paddled me out, right toward the deer; he was swimming directly towards us and did not notice us at all. When they are run into the water by dogs their entire attention is fixed on the dogs, and you can paddle right up to them before they see you. We paddled quietly on, and the deer came right on toward us. I soon saw it was but half grown and felt more ashamed than ever at the work I was engaging in.
>
> I let him get within about forty feet of us and fired; he plunged up out of the water and swam on, though I could see the blood running. I fired again, and fired a little too high, and as it was my choke barrel the shot went like a ball and missed him. Then I took more careful aim and fired,—and he sank like a stone.
>
> We paddled up and caught him and took him ashore; he was only in about five feet of water. He was a young buck, only half grown, with the little dappled spots on him yet. *I felt thoroughly ashamed of myself.*

Despite Frost's dislike of deer hunting, he executed one noteworthy painting of the subject, lithographed in color in 1890 by Bradlee, Whidden & Co. Deer hunters will recognize this scene as the classic moment of truth. The deer is poised at the edge of the stream and seems to sense another presence. The hunter crouches low, taking aim, almost afraid to breathe, yet cannot clearly see the buck's antlers which nature has

October Woodcock Shooting, 1933–34, set of four lithographs.

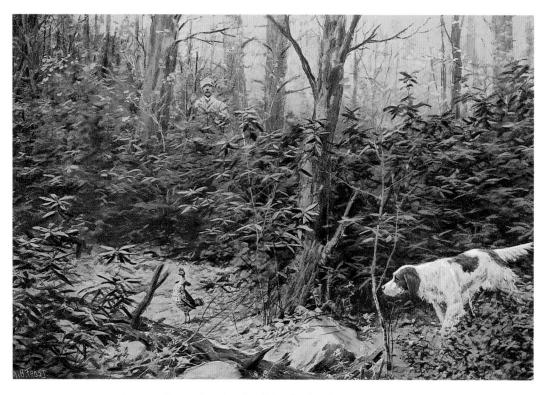

Grouse Shooting in the Rhododendrons, 1933–34.

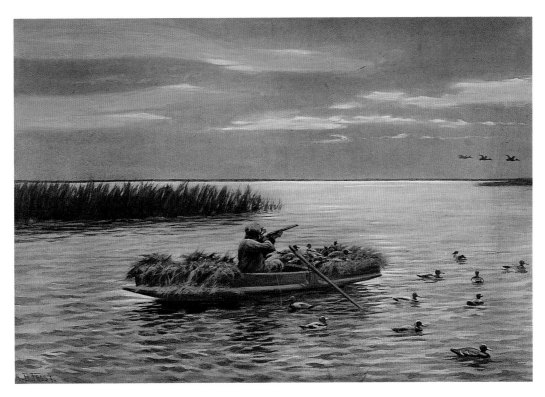

A Chance Shot while Setting Out Decoys, 1933–34.

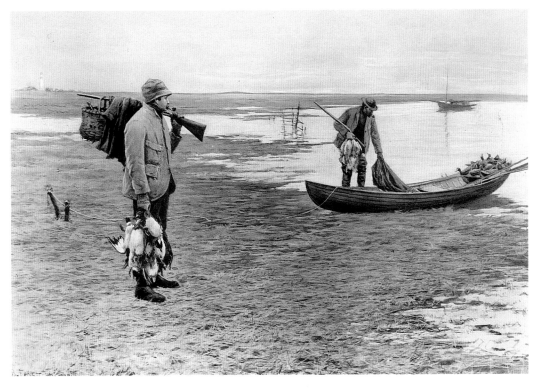

Coming Ashore, 1933–34.

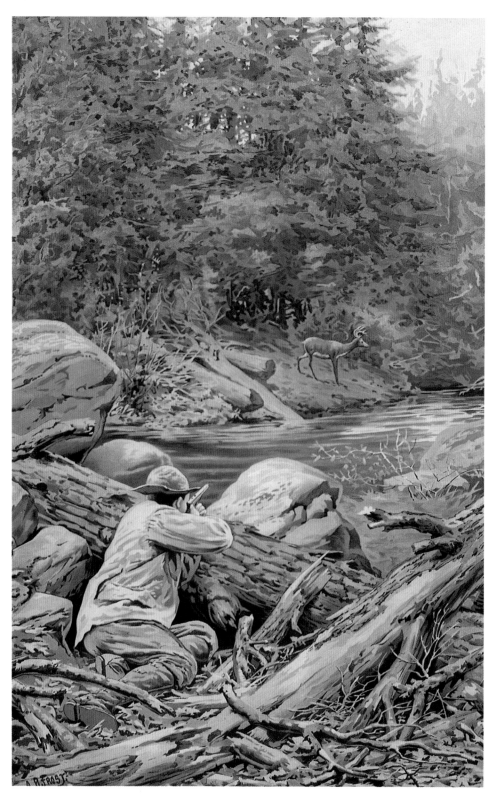

Deer Hunting, 1890, lithograph.

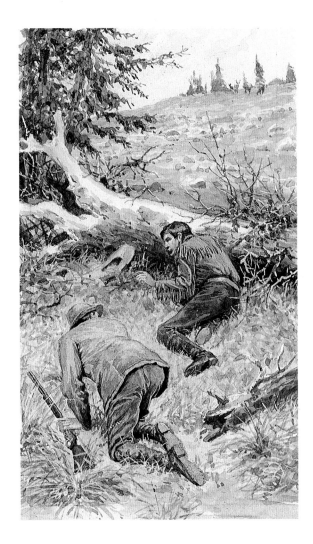

Stalking Deer, c. 1895, watercolor.
Private Collection.

blended into the brush and foliage of the background. In another scene—a very small watercolor—two hunters attempt to stalk a small herd of deer grazing in a meadow. With the skill of a miniature painter, Frost depicts the does nonchalantly grazing, but the buck is alert, head up and ready to sound the warning snort that will send them bounding off, white tails flying.

From 1895 until 1900, Frost illustrated a series of calendars for the Winchester Arms Company. Big game hunting scenes are shown: bear, antelope, moose, caribou and mountain goat hunting are displayed in large format in the upper section of the calendar, while small game scenes illustrate the bottom. Large numbers of these

Winchester calendars were tacked on the doors in country kitchens. Many talented amateur artists innocently copied the shooting scenes from the calendars, and sometimes quite skillfully, right down to the artist's signature. Unfortunately, in recent years some of these abandoned copies have been resurrected from dusty attics and have found their way into country auctions or antique shops.

These copies were not intentional forgeries, made to deceive, but Frost collectors should be aware that they exist and should be forewarned. Over the years, many copies of *The Conciliator* (the hunter offering the bottle to the farmer for permission to hunt his land), have reached the market, all claiming to be the original.

One of the disadvantages of owning a rare book in truly fine condition is the risk of soiling, creasing or tearing the book while attempting to read and enjoy it. Such is the case with the rare 1899 *Harper's* portfolio, *Sports and Games in the Open*, which contains no less than fifty-six black and white plates by Frost, measuring 16½ by 11½ inches, and loosely inserted in the portfolio. Each one has its own attached tissue guard with the title printed on it. The risk of damage makes it extremely difficult to handle, and to simply admire the illustrated board portfolio, realizing that the plates are all neatly stacked inside, unsoiled and undamaged is hardly an inspiring experience. To anyone who thinks of Frost solely as an artist of men with guns and dogs, this portfolio dispels that notion. All are outdoor images, but the portfolio mixes hunting scenes with numerous examples of fishing pictures, bicycling scenes, a few genre pictures, and illustrations of one of Frost's favorite pastimes—the game of golf.

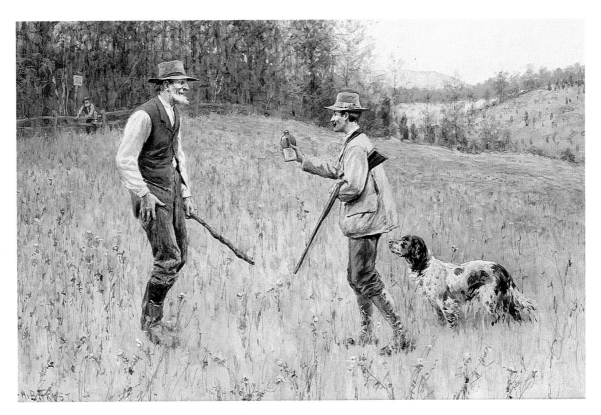

The Conciliator, c. 1900, gouache. Private Collection.

Quail Shooting, c. 1895, oil on canvas.

108

Still Life of Hanging Ducks, c. 1905, oil on panel. Private Collection.

The Frosts Move to Europe

*D*uring the last five years that he lived in New Jersey, A. B. Frost was at the very zenith of his career. The Uncle Remus illustrations had gained him worldwide fame and the *Shooting Pictures* established him as the nation's finest sporting artist. As an American book illustrator he had more than seventy volumes to his credit, no less than eight for Joel Chandler Harris alone, with *Uncle Remus Returns* yet to come. He had just finished his illustrations for Mark Twain's *Tom Sawyer Abroad*, *Tom Sawyer Detective, and Other Stories*. Practically every issue of *Harper's* and *Scribner's* contained his work, either for stories or as illustrations of shooting pictures or genre scenes.

Certainly at that stage of his career, Frost had more than fulfilled even the most ambitious goals of any American illustrator. He had reached the loftiest pinnacles of success in his field. Inwardly, however, Frost realized that it was becoming progressively more difficult for him to satisfy his own extremely self-critical eyes which were just now beginning to give him the danger signals of failing eyesight. "Moneysunk," their stately old homestead with its nearly 130 acres, was becoming more difficult to care for. His two boys, Arthur, Jr., and John, were teenagers and had already shown talent and interest in becoming artists. Frost had their futures to look forward to, and his

own desire to succeed as a *painter* was growing strong as well. He wrote Daggy in December 1903:

> I quite agree with you as to the simple side of life, I wish to Heaven I could get nearer to it. We live very simply, it seems to me, in some ways, but we have too big a place and it costs too much to run it. I have it for sale and I mean to push it for all I am worth. I am sick of it and I want to get away from this lot of money worshippers that surrounds us. We see almost no society, for we can't keep up the pace set here and don't want to. I am going to get out as soon as I can. I am laying track already and next summer may see us in New Hampshire and next winter in New York. Whether we sell the place or not, I can shut it up and save a lot of money.

Frost was being typically self-critical in his letter to Daggy. Although Mr. and Mrs. Frost were not socially prominent in the Morristown area, they had a host of close friends and the successful and distinguished red-bearded artist caused a stir wherever he appeared. The Frosts were particularly friendly with the Frank Stocktons, Robert Footes, Louis Thebauds, W. Alston Flagg—who advised Frost on financial matters— and the Charles Scribners. His pictures had already made their way into the collections of such prominent New Jersey families as the Twombleys and the Frelinghuysens and it is certain that his letter to Daggy did not refer to these people. It seems that Frost, in his letters to Daggy, purposely withheld any evidence of his own good fortune from his very best friend who was still struggling to gain his foothold in art. He wrote again to Daggy in December 1905:

> This Christmas time is hard on a man whose eyes are not good. I am having more trouble with my eyes, head-ache and nervousness and I can write but a little at a time . . . I want to sell or lease this place and go to Paris to live, indefinitely, no plans, stay if we like it, come home if we don't.
>
> I am working hard for Collier's and saving money to live on when we go abroad. I am going to say goodbye to illustration when we go. There will be no brass bands and fuss when we go, but when I go I go out of illustration for good, *I think*! You can't tell, I may be teaching a young ladies school next.

In the summer of 1906, the Frosts finally sold their house at Convent Station. After attending to the exhaustive details that were necessary to settle their affairs, the family sailed for Europe, stopping first in London. In a letter to Daggy, dated August 17, 1906, Frost wrote:

> We saw a good deal of London in our week and went to the National Gallery a good deal. It is a magnificent collection in a wonderful gallery. There are some wonderful old Masters, and a great many of them, too ... We saw the New Velasquez, the nude "Venus" and a grand piece of flesh painting it is, we just happened in on the very last day of the Royal Academy Exhibition and we saw it pretty thoroughly. It was very bad. There were not six good pictures in the 1400 oils, but some very good watercolors. I don't like Abbey's picture and I don't like Sargent's. The English paint just as they did 25 years ago, hard, finished tight stuff, with the same mawkish sentiment, and they all paint alike. Their best men did not have anything good in the exhibition. We went to the Tate Gallery where the contemporary painters are represented by one or two examples of their best work, and there are some very good pictures among them.

Frost fell in love with the English countryside:

> We are enjoying it very much. We walk and paint when we can but the weather is so beastly it is very hard to do anything ... I wish we could settle in England. It is a mighty fine place to live in, but English Art is too much for me, I couldn't contemplate the prospect of my boys absorbing any English Art with anything but dismay.

Following their original plan, the Frosts stayed only briefly in England, then moved on to Paris in September 1906. Frost found it rather hard to get into full swing with his work. With its erratic mixtures of snow, rain and intermittent patches of sunshine, he found the Paris climate too difficult for him to attempt an important canvas, so he confined himself to studies and sketches. He also discovered that it was not easy to break away completely from illustration. The American publishers and magazines continued to send him manuscripts and assignments, and, considering the high cost of the trip abroad with its hotel living and other heavy expenses, Frost was rather grateful

for the opportunity to replenish his diminishing coffers. He consoled himself with the fact that he could commence his serious painting in the spring, after the weather settled down to a more consistent pattern.

While in Paris, Frost renewed his friendship with Charles Dana Gibson, the well-known illustrator of the famed "Gibson Girl," a classic beauty who was always portrayed surrounded by hordes of properly attired, handsome young men. Like Frost, Gibson was establishing a studio in Paris for the purpose of concentrating on painting so the two "ex-illustrators" had a common denominator at this time in their friendship which was to continue for more than twenty years. Through Gibson, Frost became acquainted with another American artist in Paris, Frederick MacMonnies. MacMonnies's letters to Frost reveal that the two visited each other often in their respective studios, sharing advice and encouragement.

In the late spring of 1907, the Frosts moved to a country home at Giverny par Vernon, Eure. It was a picturesque French town and a favorite for artists, just a few hours from Paris by train. They rented a suitable cottage, just a block away from the great French master, Claude Monet, whom Frost greatly admired.

The elder Frost had long anticipated his first summer in France as the opportunity to concentrate on his own painting. However, he became deluged with difficulties and Mrs. Frost became quite ill and was bedridden for several weeks. Early in 1908, he wrote to Daggy:

> I have absolutely nothing to show for my time, nearly two years. I paint all the time but it is poor stuff and I destroy it all. Last summer was a complete disappointment, but it couldn't be helped. We had to go where it would do Emily the most good. I am counting on this summer to work. I hope nothing will prevent it, with a house in the country I ought to be able to paint something worth while . . .

Frost's inability to concentrate undoubtedly resulted from concern over Mrs. Frost's health and further difficulties of his own, which by now included a hernia. He wrote again to Daggy in September 1908. In his letter, the typical old-time Frost humor began to sift through:

I had planned a lot of work and here I am knocked out of a month, for I won't be able to work for another week and the shooting season has been open ever since I went to bed. I had been looking forward to the shooting all summer as my one chance to get any fun. I haven't had any pleasure since I came to this country, no golf, no anything, and this was to be my chance, it is rotten hard luck. Jack goes out quite often and has killed quite a number of partridges and rabbits. He is not shooting as well as he used to and I think he needs someone to steady him and tell him what he is doing, but he makes some good shots. He got a double on partridges the other day. There is a good deal of game. Jack has seen pheasants and hare and two deer, but did not get shots at them. Deer and boar come quite close in the houses here after the shooting on the preserves opens. We have had pretty good fun, fishing all summer.

Frost produced some fine watercolor studies of the French town, the old stone barns, stone walls, quaint churches and flower-lined roads and paths. His French landscape studies were done with a sensitivity that captured the feeling and atmosphere of the country. One of his very best canvases from this period is a lovely Paris street scene in the winter. The treatment of the slushy snow on the sidewalk along a masonry wall, and the impressionistic blending of the leafless trees into the foggy background created a beautiful composition of Paris in the winter.

After a few years in France, however, he felt that his painting had not progressed to the point where he could become recognized as much more than an ordinary painter. In June 1909, he wrote:

> I paint, but not with the idea of ever making a painter, I simply get some fun out of it. I find my color blindness too great a handicap to overcome, even putting aside the other difficulties. I am going to make a book and it will fill my time for all next winter and maybe more. I think I can get some fun out of it, and possibly some money, too. It will be a collection of everything I can do, caricatures, serious figure drawing, bits of old French towns and farm houses, and American country bits, a little of everything. It will be fun to do it.

In the spring of 1911, Frost's streak of hard luck hit its climax when he discovered that both his sons had tuberculosis. This was a sad and bitter blow to Frost, as the health of his sons was to plague him for the rest of his life. He wrote to Daggy:

A Paris Street in the Snow, 1910, oil on canvas. Private Collection.

TOP, LEFT: *A Summer Landscape*, c. 1891, oil on canvas. Three French landscapes, c. 1910, watercolor.

Postcards sent between John Frost and his father. LEFT: Portrait of A.B. Frost by John Frost, 1911, watercolor. BELOW: Self portrait by A.B. Frost, 1912, pen, ink, watercolor and collage. Private Collection.

RAINBOW TROUT FOR STOCKINGS

The main thing at present is that Jack is sick. Too much work in unaired studios and growing fast have used up his strength and he is in bed for a time. I feel anxious about him, he is not strong constitutionally. I am afraid Jack will be on the sick list for some time and his Mother and I are worried. We have had a hard winter in the matter of health. We all have had very bad colds and Arthur still has his, I am just about over mine. I lost three week's work, didn't go to the studio in that time and as I have all the illustrating I care to do it was rather a loss . . .

Six weeks later he wrote again from the Hotel National in Davos-Platz, Switzerland:

When I wrote you last month about Jack being ill I knew he had tuberculosis, but I did not know the extent of the disease. Soon after I wrote you our physician in Paris consulted the Paris specialist and they decided the best thing to do was to take Jack to Doctor Turban's Sanatorium here in Davos-Platz. We came here with him five weeks ago and he was put to bed at once, and yesterday was the first time he has been up . . .

Arthur looked wretchedly and has had a succession of colds all winter. Dr. Turban examined him and found his lungs were in an inflamed condition and advised him to take a preventive cure. They have taken an X'ray of Arthur's lungs and it confirms their diagnosis exactly. . . . (later) I am doing absolutely nothing. I will try to get some painting going soon. I was so knocked out and upset by this terrible thing that I felt fit for nothing for a while. I had made arrangements to work for Colliers and Scribners and would have been making a fair income and have a good time, but I have to give it all up for I can't work here. I will have a big studio when we get settled and get to work again.

With both his boys in the sanatorium, Frost's morale improved considerably as he watched their progress. He and Mrs. Frost were comfortable in the Swiss hotel and seemed to enjoy their stay in Davos-Platz. Although Frost's eyes were now troubling him considerably, he resumed illustrating with redoubled effort, since hospitalization expenses for the two boys were substantial.

He wrote to Daggy on April 19, 1912:

I haven't been doing much writing lately. I've been trying to save my eyes, or eye, for work. I'm making a book, in caricatures. I sent about 20 drawings to Doubleday,

Page and Co. and they are very much pleased with the thing. I'm taking my time over it and hope to produce something worthwhile. We are getting along very well. Arthur is going back to Paris to live soon. He has an apartment joining his best friends, the Bruces, and will take his meals with them. So we feel that he will be watched and if he should not be well we will know of it.

Jack is doing well. He has not had a set back since he came here, which will be a year day after tomorrow.

The book referred to in the letter to his old friend was *Carlo*, the story of a dog who comes to live with a family, published in 1913, by Doubleday, Page & Co. In *Carlo*, Frost portrays a series of hilarious antics through the book, as the dog romps playfully from kitchen to chicken coop.

Although Frost had continued his magazine and book illustration while the family was in Europe, it had been twenty years since his previous volume of comic sketches, *The Bull Calf and Other Tales*, had first appeared, and the public received *Carlo* like a long lost friend.

The New York *Sun* wrote:

Ever since A. B. Frost made his bow as a drawer of pictures, which is as far back as most of us can recollect, he has managed to give his animals all the requisite expression without changing their natural characteristics. His beasts may be comical, but they are never caricatures. In an album entitled "Carlo," he traces some exciting passages in the life of a plain dog with no pride of ancestry. The pictures tell their own story, with no need of enlightenment from the sparing text; they are as natural, as absurd and firmly drawn as any that Mr. Frost has ever turned out and will be a joy to those that see them.

And according to the New York *Knickerbocker Press*:

"Carlo" has to be seen to be appreciated and this is the first appearance, for none of the material in "Carlo" has ever appeared in any form. Those who love children and dogs and those who love a good joke will find much merriment in this pleasant book of drawings by A. B. Frost just published by Doubleday, Page & Co. Mr. Frost is well known as one of the few artists who can improve on animals and jokes by

Illustrations for *Carlo*, 1913.

putting them on paper. Every one remembers his "Brer Rabbit," the "Tar Baby" and all the quaint world of "Uncle Remus." The whimsical drawings of "Carlo" are in the same vein.

Carlo was so popular that a second edition was published in 1924.

With the recovery of his sons from their bouts with tuberculosis, Frost decided to bring to an end the family's hapless journey to Europe. He longed to return to his former simple American country life. He had now abandoned any ambition of doing anything but occasional painting. His success with *Carlo* had convinced him that he should stick principally to illustrating. One more disappointment, however, was in store for Frost before he could sail for home. That was the decision of his son, Arthur, to remain in Paris to continue his painting with the French Modernists. Frost took the bad news with typical philosophical acquiescence; nevertheless, he was bitterly disappointed. Finally, in May 1914, the Frosts ended their eight-year absence from America and sailed for home.

A Family of Artists

*A*round the turn of the century, it was common for one or more members of a family to undertake the study of art or music. It was particularly appropriate and natural that the Frost children should follow their father's footsteps and study art. Their mother, too, was an artist of noteworthy accomplishment.

It is unfortunate that so few examples of Mrs. Frost's work remain, for she began a career as an illustrator for *Harper's* and developed a fine artistic talent. Outside of her oil portrait of her husband which appears in Henry Wysham Lanier's biography, *A. B. Frost, The American Sportsman's Artist*, plus a small, but delightful, unfinished watercolor and a fine pencil portrait of her husband, few works by Emily Phillips Frost are known to exist. According to family correspondence she threatened to destroy all of her work. However, this seems to have been more in jest than a serious threat. Nevertheless, the entire Frost family were artists of the highest caliber and the story of the Frosts as a family of artists became a sequence of brilliant, tragic and again brilliant events.

In 1905, about a year before the family sailed for Europe, A. B. Frost enrolled his son, Arthur, in William M. Chase's art school in New York. Arthur, Jr., who had already mastered the basic skills of drawing under his father's tutelage, worked hard and progressed so rapidly and skillfully that he was encouraged to study with Robert Henri, an outstanding artist of the "Ashcan School," who became famous as one of

A.B. Frost, by Emily Frost, c. 1900,
pencil on paper.

the "Eight," a group of artists which included Arthur B. Davies, William J. Glackens, Robert Henri, Ernest Lawson, George Luks, Maurice Prendergast, Everett Shinn and John Sloan. The "Eight," also known as the "revolutionary black gang" and the "Ashcan School," were so called because they portrayed everyday, unglamorous New York scenes and characters, focusing on the slums, theaters, prizefighters and more. They were part of certain tendencies in American art around 1913, another being the Modernists.

During this period of A. B. Frost, Jr.'s life, he painted a remarkable portrait of his father which is now in the collection of the Philadelphia Free Public Library. Young Arthur's brother, John, had already begun his career, too, under his father's supervision.

A.B. Frost, by Arthur B. Frost, Jr., 1906, oil on canvas. Rare Book Department,
Free Library of Philadelphia.

A. B. Frost was full of hope for his artistically-talented sons when the family sailed
for Europe in the summer of 1906. They were to be enrolled in the Académie Julian
in Paris and become fine painters. His plan was simple—with his sons thus busily
engaged, he would concentrate on his own painting and abandon illustration com-
pletely. He had it all figured out, but he had not figured on the French "Modernists"
and the "Salon d'Automne." He wrote to Daggy, on November 1, 1906:

> . . . Jack is fine; he is very anxious to go to work in the Julian School and I am
> going to let him—he draws well and is full of imagination, and he is happy in his work.
> Arthur is causing us great anxiety—listens only to the damned fools who have had
> something to do with the Chase school. I have seen this contempt for drawing and
> painting and all technique and it had ended in "impressionism" which was then the
> refuge of the incompetent.—Paris appears to be full of fools to judge from the Autumn
> Salon. I can't understand it all. I laughed the first time I saw it, but not for long, it
> grew serious enough before I got through the rooms. You can't believe till you see it;
> as Dana Gibson said yesterday to me, "If that is painting, your cook can paint."

A month later he wrote again:

> You don't understand about Arthur, evidently, he is making a bad mess of it. He
> might as well be in Morristown for all he is getting out of Paris, painting impressions
> of nude models is not the way to learn to draw and paint. He is old enough to go on
> his own way and I will not be responsible for such foolishness. Jack is going into the
> Julian School on January first. He is doing very well with me and has advanced quickly
> with his charcoal drawings. He couldn't work a large drawing when he came here. We
> are all very well and getting along comfortable. We take French lessons but Mrs. Frost
> and I are pretty slow, the boys do well. I am making illustrations, only doing what I
> can do from nature. We will probably be in the country all summer and I will find
> plenty of stuff to do.

Although A. B. Frost did not realize it at the time, or at any subsequent time in his
life, his son, Arthur, would join a group of young artists who played a significant role
in the history of modern American art.

When Frost enrolled his two sons in the Académie Julian in Paris, in early 1907,

his older son, Arthur, had already been well grounded in the rudiments of art. Arthur, Jr. had studied briefly at the Pennsylvania Academy of Fine Arts (where he had exhibited with recognition) and more intensively under Robert Henri at the Chase school in New York. Although he applied himself diligently to the basic work of the Julian school, the new color movement of the young modernists had already caught his eye and had captured his imagination.

By mid-1907, Arthur Frost, Jr., had met another young American painter, Patrick Henry Bruce, who, like Frost, had studied under Henri at the Chase school in New York. Bruce had come to Paris in 1904 after a promising beginning when he had exhibited at the National Academy of Design. In Paris, Bruce had continued his early impressionistic flowing style which revealed his Henri training, but by the time the Frosts were arriving in France, Bruce had become infatuated by elements in the modern movement in painting and had been admitted to the frequent Saturday evening salons at the home of Leo and Gertrude Stein. Through Bruce, Arthur met the Steins and gained admittance to the charmed circle where he came under the influence of Henri Matisse and Picasso.

Much to the consternation of his parents, Arthur soon dropped out of the Académie Julian and enrolled in Matisse's school, which was just being organized. The elder Frost displayed his bitterness in a letter to Daggy in March 1908:

> Arthur is now working in a school just started by Henri Matisse. He has reached the bottom, he can't degrade his talent any further. His studies are silly and affected and utterly worthless. He will come to his senses too late, I'm afraid.

Three months later, Frost again wrote Daggy:

> I am sorry to say Arthur is just the same. I can see nothing in his work but affectation. No one can see nature as he paints it. He can explain that it is a color scheme or some such thing, but he brings home a canvas with a smudge of rank green for a tree with pure black for the stem and some blue for a sky and harsh yellow for buildings. He pretends to say that he sees nature in that way, but as it is the way the

whole damned crew of Matisse followers paint landscape, I simply doubt it. Why do they *all* see nature as Matisse sees it? People who follow their own bent in art don't all see alike. It is a dreadful thing to see a boy of his talent wasting his time as he does.

In a letter a month later Frost's contempt for Matisse reached a near-comical level:

> He is a charlatan and a fake and a pretty dirty one, too. He sold Arthur a little panel about 10 inches long that he painted in an hour for $80.00. I think a man who would sell one of his pupils, and a boy at that, such a thing for such a price, is a dirty mean cuss.

It is not difficult to understand the elder Frost's concern regarding the growing tendencies in his son's art. The young Frost was entering a period of transition, by stages, into movements which ultimately became known as Cubism, Orphism and Synchromism. The young circle of artists who were excitedly experimenting with these principles in art around 1906-1916 were creating storms of critical protest. It would be half a century before a sound, critical assessment of their work would be attempted.

So quickly did Arthur Frost, Jr., grasp these concepts that he exhibited his first painting in the Salon d'Automne in 1907, less than one year after the Frosts had arrived in France. Young Arthur tried in vain to explain his feelings to his parents, but his father's academic principles were so deep-rooted that he stubbornly refused to even try to understand his son. Although the elder Frost, himself an admirer of Renoir and Monet, had felt the liberating effect of William M. Chase while studying with him, and had later translated Chase's teaching into his own progressively more impressionistic canvases, he still could not accept Matisse as anything but affectation.

At length, young Arthur, unable to embrace completely the rudimentary principles of the Académie Julian and equally unwilling to reject the teaching of Matisse, gave up painting altogether. He began to study at the Sorbonne; first it was literature, then music—so intensely in fact, that he bought a piano and actually attempted to compose music. Finally, after a long and agonizing self-evaluation, he returned to painting. Taking an apartment of his own in the same building with his close friends, the Bruces, he resumed his painting in earnest. He wrote to Daggy:

A. B. Frost, Jr., c. 1916.

Dear Uncle Gus:

I can write to you now as I have no more theories and now can write about realities.

I have been through hell's fire and damnation and have come out of it all with an unshakable conviction of myself as a *painter*, a first class painter.

I was in a rotten state and thought I had no gifts just because my gifts weren't somebody else's gifts. Everybody jumped on me. Everything I did the invariable answer was "*dead*." Hearing myself called dead so damned often I began to think and believe I *was* dead and bought pictures of a friend of mine instead of painting them myself, admired those pictures, scorned my own (although I hung some of them on the wall nevertheless). I looked more at my own pictures than at my friend's, but I thought that was just curiosity, to see their faults, such was my confidence in my friend's reasoning. But I never really learned any of this modern academy stuff. I thought that was lack of sensibility in the direction of painting and that not feeling the things I couldn't grasp them intellectually! etc. etc. etc.!!

Well it all blew over through a new friend, a real live inspired man, who brought me an audience by admiring my stuff! He saw its qualities, rough rude strength, straightforward frank painting, admired them, and I saw them! Then all my life of painting was lit up to me and I see now exactly the same quality in a drawing by me in September 1896 as in the stuff I am at work on now. And you bet I am happy! I get up at 6 every morning and go to bed at 9, and I paint. I stick to my paintings like a burr and will continue sticking the rest of my life. I have no theories. I make photographs. I copy nature. Now I see the painters thus: Corot; Renoir; Courbet; Delacroix; Cezanne; Seurat; Piccasso; Matisse; Delaunay; Bruce; (Frost)—the filling out of this name is my job.

I have 4 pictures started and I work on them all the time. Sunlight, morning, white houses and others against sky and sea—10 m. afternoon—house with orange roof and vermillion shutters against sky—12F.

Gray morning—Houses against sky and sea—15F. afternoon—black pony against grass. (The pony is in colors ranging from ultramarine to alizarin, crimson. He contains also red, greys, and a little black.)

I wish I could see you for you are a painter who paints nature and we are therefore brothers. My love to you and good luck with the motif. Stick to it.

Yours ever,

Arthur Frost

On July 28, 1913, Arthur wrote to his mother, from Pouldu in Finistère, France:

Dear Mother:

Pouldu is wonderful and I am perfectly content, well and hard at work. I have started 3 pictures, one early morning grey, one morning sunlight and one afternoon sunlight. All 3 landscapes of modern houses. The sea is in two of them. I intend to work long on all of them. I get up at 6 and go to bed at nine.

There has been one colossal painter in our epoch, Cezanne. Renoir is also all right. I will do like Cezanne the rest of my life, study nature long and intently and see more and more clearly. The weather is warm and perfectly clear.

Interrupted only during the period of Arthur's recuperation from tuberculosis in 1912-1913, he and Bruce lived, worked and studied together in close association for nearly four years. Their work advanced in stages, beginning with Renoir-inspired

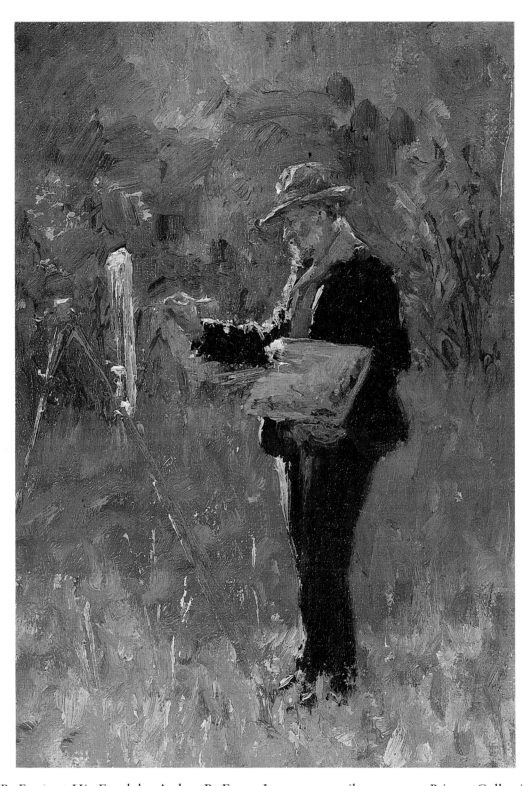

A.B. Frost at His Easel, by Arthur B. Frost, Jr., c. 1915, oil on canvas. Private Collection.

Impressionism, then through the Matisse-influenced period, to Cezanne-Cubist patterns, then to the color principles of Delaunay, and, finally, to individual expressions of all they had absorbed.

There is an interesting letter from Arthur to his mother, undated but probably written during the period of transition, in which he mentions Cubism:

> Last night I went to Mr. & Mrs. Steins. Talked some time with Leo Stein and Pat, about cubisme.
>
> Today I take Bruce to the Colonne concert, at 2:30 P.M.
>
> You wanted to know if the cubists intend that the subject be obscure in their pictures, I tell you frankly *I do not know!* The cubists are called so in bulk, but they all don't paint in cubes, nor is there any one thing by which one can class them as a crowd unless it be the obscurity of the subject. However, one can paint a collection of lines without suggesting some object or objects to the mind of the person who sees the picture. Picasso painted a thing which I called, as soon as I saw it, the machine-shop picture. It does look like a machine-shop though it was not meant to look like anything at all.

Synchromism as a movement in art was actually founded by two young Americans, Morgan Russell and Stanton Macdonald-Wright, who in 1913 exhibited twenty-nine of their paintings at the Galerie Bernheim-Jeune in Paris. This new principle involved a great deal more than the traditional uses of color and light in painting, and their exhibit in one of the most prominent French galleries caused quite a stir of criticism and misunderstanding, much of which still continues today.

Although Arthur Frost and Patrick Bruce, as well as Robert Delaunay—who had already begun to have tremendous influence on both of them—never allied themselves with the Synchromists, they had been experimenting with the principles of color and light to the extent that their work was similar to the Synchromist movement in many ways.

The theory in the work of Frost and Bruce involved color application, the use of contrast, and the fusion of colors to produce form, rather than the use of lines to produce form. Form was also created by harmonizing small patches of color. Underly-

ing the whole concept was the idea that form would be more forcefully created by intense color blending.

It is tragically unfortunate that only one or two examples of Arthur Frost's painting from this period are extant. His major remaining work, shown at New York's Knoedler Gallery in the fall of 1965, in an exhibition entitled *Synchromism and Color Principles in American Painting 1910–1930* is a remarkable canvas called *Harlequin*. Arthur describes the painting in a letter to his father dated October 22, 1914:

> I liked the horse I did which I wrote you about very much. I have since done a Harlequin (a no. 5) in oil. A figure with his back turned, in tights made like a patch work quilt of all color. I enclose the drawing I made it from, but the drawing is not standing on its feet, the painting is. It is very pretty. I have now 17 things which *go*, ranging from 3 to 25.

Late in 1914, several months after the rest of the family had sailed home for America, Arthur Frost, who at the time was living and painting with the Bruces, managed to get into considerable trouble with the French authorities over a rather trivial incident. He explains it in a letter to his parents, dated December 13, 1914:

> I don't believe I have told you the real story of the arrest and it isn't in the report I made for Conner which I sent to Jack. It was like this. Pat and I went down to the quay on Friday morning to see a batch of German prisoners which had just arrived. We went up a street. We had permission from a sentry armed with a gun and bayonet to follow the line of the curved arrow instead of going all around the block of houses, so as to get on the sidewalk behind the line of sentries. While we were on the guarded ground the military commander came rushing up and grabbed Pat by the shoulders and shook him hard 3 times. Pat protested and said the sentry let us pass. The Colonel didn't answer and he rushed up to me and said "Allez-vous en d'ici" exactly as one talks to a dog. I stood still, whereupon he said "Voulez vous que je vous fasse en aller de force?" I answered "Allez y." He then arrested me.
>
> That is all there was to it.
>
> I am sorry that you saw all those rotten newspapers as I don't pretend always to do dignified and right things and I would not blame anybody seeing those articles for thinking that this time I had acted like a scrub, it was the Colonel who made an ass of himself and acted like a jumping jack.

Harlequin, by Arthur B. Frost, Jr., 1914, oil on canvas. Private Collection.

I never gave any cigarettes to prisoners, except one that an English speaking prisoner asked me for in the boat coming from Nantes. One time in the woods back of our house I gave them some tobacco but in the sight and under the nose even of a French soldier. We never had any prisoners in our house and never talked to any anywhere near the house.

Only during his trial did Arthur realize the extent of his troubles! He and Bruce had apparently been under surveillance by the French on suspicion of espionage and his arrest had simply been a fabricated incident so they could arrest him and put him in jail. His youthful inquisitiveness regarding the German prisoners of war caused him trouble on more than one occasion. In another letter he wrote to his brother, Jack:

It was rather a spooky feeling when that old s.o.b. at Quiberon said he was going to shoot me. I tell you frankly at the time I didn't know but that he might be ass enough to do it and drunk enough. He was drunk. I determined to die game. It was a rotten feeling but gave me an insight into this war business. I just thought "Well, if it's all up, it's all up, I can't do anything about it. I'll just go out well so that none of my family or friends will be ashamed of me." I didn't sleep a wink that night in the hotel however, altho' by that time I knew I wouldn't be shot. I only thought I would be shot for a few minutes. That was enough, when he told me he would shoot me I was sitting at a cafe table far from the fire. It was cold and I began to shiver. I thought "this old s.o.b. if he sees me shiver will think I'm scared" so I went and stood with my back to the fire right next to the old goat.

Finally, on December 14, 1914, Arthur was able to send his parents, who by this time must have been near the end of their ropes, the following cable:

ACQUITTED NEWSPAPERS DISGUSTING ALL DIGNITY ON MY SIDE FROST

Two weeks later, Arthur, greatly sobered by his harrowing experience, and by now more than a little homesick cabled his parents the best Christmas present he could have given them:

SAIL JANUARY FIVE ROCHAMBEAU HAVRE ARRIVE NEW YORK FROST.

Back Home in America

*A*fter the inevitable and joyful reunions with the Daggys, Harpers, Scribners, Doubledays, Gibsons and other artists, as well as friends around Morristown, the Frosts made a motor tour of New England looking for a country home. They finally settled in Wayne, Pennsylvania, a suburb of Philadelphia, in a large airy house with high ceilings on a hill surrounded by trees.

In October 1914, the Society of Illustrators gave a homecoming, testimonial dinner in honor of A. B. Frost. Here is a report of the event as it appeared in the *New York Morning Telegraph*, on October 17, 1914:

Three hundred members of the Society of Illustrators from all parts of the United States attended a dinner given to A. B. Frost, dean of American Artists, at the Hotel Brevoort last night. Charles Dana Gibson, president of the society, was toastmaster, and in the only address of the evening referred to Frost as the most venerable artist in America and said that he deserved the distinction of being known as dean among them.

Moving pictures, illustrating many of the older cartoons and sketches of Frost were shown. "Dizzy Joe," a comic sketch which was first published in Scribner's Magazine several years ago and resulted in a series of tramp sketches by Frost, was enacted before a moving picture camera and reproduced last night. Winsor McCay made several sketches of "Gertie," showing the antics of a dinosaurus, and also of "Little Nemo."

James Montgomery Flagg was shown in the character of Si Stebbins, Will Foster and David Robinson made up the Bull Cow, Charles Voight and Louisa, a mule, George Kerr, a cat and Willard Fairchild a dog.

Among those present were Frank Doubleday, Alexander Harrison, Dan Beard, J.

W. Alexander, Peter Dunn, Arthur Scribner, Rose O'Neill, originator of the Kupie dolls; Lady Duff Gordon, Mary Wilson Preston, Walter Trumbull, Djuna Chappel Barnes, Grantland Rice, C. Allen Gibson, Thomas E. Hardenbergh, C. D. Williams, Montague Glass, Harry Dart, Arthur William Brown, George Kerr, and W. A. Rogers.

Frost, himself, had detested the thought of a testimonial dinner, and it was only after considerable coaxing from Charles Dana Gibson that he agreed to attend the affair. Gibson had written:

> Can you let me know about when you are to get here? The boys (The Society of Illustrators) want to give you a blow out. There is no possible way of your dodging it so don't make a scene, but give in to it gracefully.

The Frosts lived comfortably in Wayne. For the first time in years, Frost felt peacefully settled in his native land. Particularly comforting to him was the fact that the publishers continued to backlog him with assignments. He was just as busy as he had ever been. He prided himself that, as the nation's oldest illustrator, his work was still in demand, although he did admit that his eyes troubled him and that he found it necessary to spend twice the normal amount of time to get a drawing that satisfied him.

He was very pleased with Jack's work. Jack was doing occasional illustrating on his own, and although he wanted his son to become a *painter*, not an illustrator, the elder Frost felt that Jack should acquire a little independence, so he did not interfere. Frost realized that he had already interfered too much with Arthur's work.

Soon after returning to America, Arthur Frost Jr. set up his studio on East 14th Street in New York City, and applied himself more diligently than ever to painting. He was anxious to produce a truly important painting, embodying all the color principles he had learned in Paris, and he was soon hard at work on a very large canvas. He spent several months on the painting, often rejecting and repainting several areas in order to achieve exactly the desired result. When the work was nearly complete, he received a shipment of several paintings from Bruce which were to be sold in New

York. Seeing Bruce's recent work for the first time in several months, Arthur perceived a new dimension in his best friend's art, which harmonized elements of black and white into the color spectrum. This new dimension affected Arthur so strongly that he repainted his canvas entirely, incorporating Bruce's newly discovered innovation. In 1917, Arthur's painting was put on exhibit by the Society of Independent Artists, of which he had been made a director.

While in Paris, Arthur's life had been solely dedicated to advancing his art. While his recreational pursuits were principally confined to the type of activities conducive to the recovery of the tubercular patient, his activities in America gradually and progressively became just the opposite. Late in 1917 his bohemian dissipation climaxed itself and he became violently ill. Scorning medical assistance, he died very suddenly on December 7, 1917, four days before his 30th birthday.

In *Scribner's* magazine in May 1918, Walter Pach wrote in his article, "Arthur B. Frost, Jr.":

> The passing of a young artist, full of life and rich in promise as he was, might not seem an event capable of arresting attention for long, in times like these when great numbers of young men are being swept to a death whose reason we cannot comprehend,—at a time also when one of the greatest sculptors of the modern world and one of its finest painters have gone from among us. But it was precisely because his career was unfinished, because he had gone far along a course that might have yielded results defining the thought of our day and of its immediate morrow, that the death of Arthur Burdett Frost, Jr., came as a grievous shock to all who knew him or his work.
>
> . . . The results were evident by 1913 when we find young Frost as one of a group of painters—Delaunay was probably the most prominent of them—who had their own word to say. They were all men who had the scientific-aesthetic research of recent years well in hand, they had passed the groping state in getting a balance between realistic and abstract form, and their pictures of aeroplanes, clouds, the sun and other heavenly bodies were part of the movement of creative art for which our time will be remembered.

A. B. Frost never completely recovered from the shock and grief of his son's death. His sadness remained with him for the rest of his days. There is no record of family

correspondence for almost one year following Arthur's death, no letters to Daggy, just a blackout.

Harlequin is one of the few canvases in existence from Arthur's peak period. Two examples of his earlier French painting are in a private collection. The Philadelphia Free Public Library owns the portrait the eighteen year-old boy did of his father, and a few minor examples of Arthur's work as an early teenager have been found. At the time of Arthur's death, a young painter, James Daugherty, later of Weston, Connecticut, maintained a studio near young Frost. Daugherty had felt the impact of the new treatment of color principles in art and he subsequently made significant contributions of his own to the new movement. Daugherty had acquired two untitled canvases from Arthur Frost, Jr.; one of two figures seated in a French garden; the other, a large unfinished abstraction of 1917. The few examples extant from the young artist's mature period make one wonder what his career might have been, had he lived a full life.

Outside of these examples mentioned, no other work by Arthur Frost, Jr. has turned up. The whereabouts of the large canvas exhibited in 1917 at the Society of Independent Artists is a mystery, although a suspicion remains that his father, shocked and grief stricken, went to his son's studio to clean up his personal effects and destroyed everything.

Practically nothing is known about the Frost family affairs for a twelve month period following the sudden death of Arthur Frost, Jr. in 1917. There are no letters, no illustrations from this period—just a blanket of grief covers the entire year. Finally in December 1918, Daggy sent A. B. Frost the portrait that young Arthur had painted of his father in 1905, and which had been inscribed "to Uncle Gus from Arthur B. Frost, Jr."

On December 23, 1918, Frost wrote Daggy the following letter:

Dear Gus:

 The picture came safely last evening and I am more grateful to you than I can tell you. I know how much you valued it and what a sacrifice it was to give it up and I thank you from my heart.

It is even better than I thought it was, a fine thing for a boy of eighteen to do. Mrs. Frost is just as thankful as I.

We will have no Christmas. We could not have it without our boy.

I will write you again soon. I find it very hard to write anything and I have many kind letters to answer.

I am thankful that I can see that calm untroubled beautiful face all the time. Thank you again old man.

Affectionately,
A. B. F.

Frost's grief over the death of his son is climaxed in the following letter to Daggy, written January 5, 1919:

Dear Gus,

I am very glad to get your letter and to learn that you are all well and happy. You say you hope we are enjoying the Christmas holidays. They are over for us, it is the saddest time of the year for us and always will be. We have no Christmas and never will have again.

My poor boy's birthday and Christmas came close together and we made a great day of it. Jack feels as his Mother and I do about it and we pass the day as the other days. We gave Jack some money and some to the servants and that was all.

Jack is doing *very* well, he has gained a great deal of weight and looks remarkably well. Much better than he did before he was taken sick. The Doctor won't let him do much, but he works with me in my studio every morning for a while, about two hours. He has a story for Scribner's and plenty of time to do it in. I think we will go South in a few weeks and get away from the bad weather that is sure to come. So far the weather has been perfect. The three warm days last week were bad for Jack and he felt the effect, showing that he is not well yet.

Mrs. Frost and I are very well. I have no ailments and if I did not smoke I would feel quite up to the mark. I must stop for it does not suit me.

I have given up working in tone and am at work with a pen. I can't see well enough to work in tone, and can't get a suitable glass. I have just finished some golf drawings and am going to take up caricaturing with a view of getting into the syndicate job. If it goes at all it means better pay than I could get in any other way.

Caricature is with me a separate thing from my life. I can draw absurd things that

amuse others but do not affect me. I am wretchedly unhappy and always will be but I can make "comic" pictures just as I always did. I know when they are funny but they do not amuse me in the least.

I have a hard time these days. I *must* be cheerful for Jack's and his Mother's sake and it is not easy. I wish with all my soul I were dead and with my boy and I must grin and chatter. It can't go on much longer. I will soon be 68 and my time will come some day.

No, we are not planning to go back to Phila. I would like to go but it is not the place for Mrs. Frost. She does not like it. We will stay where we are for another year. That is far enough ahead for us to look. I try to live from day to day, I wish I could stop thinking and be a machine.

Frost was, understandably, at the depths of despair at this time of his life, yet he still possessed his skill and technique as a master draftsman. Late in 1919, he painted an autumn landscape in watercolor that was as brilliant as anything he had ever done. His pen-and-ink line-drawing illustrations for *The Epic of Golf* by Clinton Scollard, published in 1923, were equal to the very best efforts in his already long career, and were infinitely superior to a similar set of golf illustrations he had done for a golfing fiction volume, *John Henry Smith* by F. U. Adams, published eighteen years earlier.

In December 1919, the Frosts, without fuss or fanfare, and without any ceremonious goodbyes, moved lock, stock, and barrel to Pasadena, California. Their son, Jack, had never really regained robust health since his illness with tuberculosis in Europe. Because of this, his doctors finally told him that he must live in the Southwest.

Jack Frost left for California several months before his parents did, settling first in the desert country near Palm Springs. The change in climate had an immediately beneficial effect, not only on his health, which improved rapidly, but on his painting as well. The desert lands with their wide spaces, fertile valleys and majestic mountains made ideal subjects for landscape painting. So deeply did Jack feel the effects of this new change in environment that his work almost immediately acquired new dimension and substance. When his parents arrived later that year, Jack had already completed some important desert landscape canvases, had sold a few at respectable prices, and had sown the seed for a fine reputation as an artist of the southwest.

John Frost, c. 1925.

While Jack was in California in early 1919, his father, concerned for his son's health, wrote to him almost every day giving him advice and counsel. Frost was also concerned that his son might resume professional illustrating, since it would interfere with his career as a fine painter. He wrote:

> I think the sale of your pictures is a very good thing. It is encouraging, a man does not like to feel that he is painting all the time with no hope of selling anything. Sales are a sign of appreciation. I won't growl at you any more. You are doing just the thing I would have you do. I am so damn thankful you have cut illustration that I can't say enough about it. Don't give it another thought. You will never have time for any more illustration; it would be time taken from your painting and wasted.

In another letter he wrote:

Don't work hard when you start painting. You will have to stand and it is tiring. Just get some fun out of it and the more fun you get out of it the better the work will be. Gosh, but you are fortunate in not being color blind, it worried me dreadfully when you boys were little. I was so afraid you might inherit it, but your brown eyes led me to believe they were different. A color blind artist is a monstrosity, it is tough as I know, I would like to paint now, but I can't do anything in oil without your help. I think I can do something in watercolor as it is not so positive and I can handle it easier.

Guy and Ethel (Rose) liked my drawings but I don't, finicky and stupid, silly drawing of the trees, nothing broad anywhere, everything overdone and carried too far. Good Lord if I could see I could make better drawings today then I ever made, I feel things in a broader way—but it doesn't matter, I have *you*, you will be a very much bigger man than your Dad ever was—don't hurry—don't work for money, you will get there. *Think*, look at your work and *think*.

A. B. Frost's arrival in California, unlike his quiet departure from New Jersey, caused quite a stir in California art circles and in the press. In an interview by the Los Angeles *Times*, dated June 14, 1920, Frost said:

I have no doubt that the California influence will appear in my work, though I see a good many of my old chin-bearded friends out here, too. I understand they come out from the Middle West on every train. But a man gets most of his pictures from his head, not from the people he sees. In Paris I used to pose a Frenchman as I wished him and then draw a picture everybody would recognize as a Connecticut farmer. From the model I got the pose and perhaps expression; all the rest came from memory, from pictures in my mind as distinct and easy to draw as models, real friends I have grown to love through long association. I don't make fun of my chin-bearded friends—I love them, and simply show their whims and humours. You see, I am a bit chin-bearded myself.

What brought you to California, after being so long identified with the East? asked a friend.

Why, the—oh, you can guess. Yes, the climate. It gets warm here in Pasadena, but there's not the humidity there is back East. My son, John, the painter, was pretty run

A California Desert Landscape, by John Frost, 1923, oil on canvas. Private Collection.

down after he had the influenza, but when he came to California he grew stronger at once so Mrs. Frost and I came out, and—well, it's the most beautiful region we ever saw. And it makes me feel like working. So here we are for life.

Southern California should have a great future as an art center. It has everything Italy has in climate. One can work here the year round and there is plenty of perfect stuff for landscape and marine artists. Back East the spring and autumn are the only seasons when one can work. This region might well become the American painters' paradise.

A Western Landscape, by John Frost, 1926, oil on canvas. Private Collection.

After a few months' stay in Palm Springs, the Frosts bought a home at 529 South Madison Avenue, Pasadena, and settled down for the rest of their years. Frost was still busy illustrating, and his work appeared for several more years, to within a few months of his death. In a 1920 letter to Daggy, he mentioned making four of the best drawings he had done in years for *Scribner's*: "Made them in crayon, at a flimsy desk in my room at the hotel. I'm wild to work again, after a long loaf I feel just like it. I'm going at it hard as I can go."

His old friend Charles Dana Gibson had just bought *Life* magazine and was anxious to add A. B. Frost to his list of contributing artists. So, for the next few years, Frost created a steady output of comic caricatures for *Life*, to the delight of Gibson and the magazine's followers. Gibson wrote to Frost on October 3, 1920:

Dear Arthur:

They have just sent me up an advanced copy of "Life" October 14th, and the best thing in it is your "On the Way to the Poles." It is you at your best, and no one else can do half as well, for you are a master, and "Life" is mighty proud to have you for a contributor. Casey says there is more to follow and if he is deceiving us we will fire him. We are out to make "Life" a great paper and you are doubly welcome at this time . . .

It was not long after that John Frost met Priscilla Morgrage Geiger, a local sportswoman, and they were married on May 20, 1922. Jack was now concentrating heavily on his painting. He was awarded Honorable Mention at the Southwest Museum Exhibition at Los Angeles in 1921; the landscape prize in 1922; the second and popular prizes in 1923; and the Gold Medal in 1924. He had now acquired a reputation as the finest landscape painter on the West Coast.

Not wanting to ride the coattails of his famous father's reputation, Jack needed considerable coaxing before he would undertake a sporting subject. Some years later his hunting and fishing companion, Eugene V. Connett, finally took him on a fly-fishing trip to the Brodhead Creek in the Poconos and persuaded him to paint a fly-fishing picture, *On the Brodhead*, and a landscape canvas of the river. About this time Jack painted a striking railshooting canvas, *Maryland Marsh*, which he inscribed and presented to Mr. Connett, who, being founder and head of the Derrydale Press, published a limited edition of fine hand-colored prints from a plate engraved after the picture.

Gradually, Jack Frost acquired a reputation as a fine sporting artist independent of his father. His hunting and fishing scenes, unlike his father's, were always done in color on canvas or a panel, and have a look of modern elegance as distinguished from the quaint, nineteenth century appearance of his father's work.

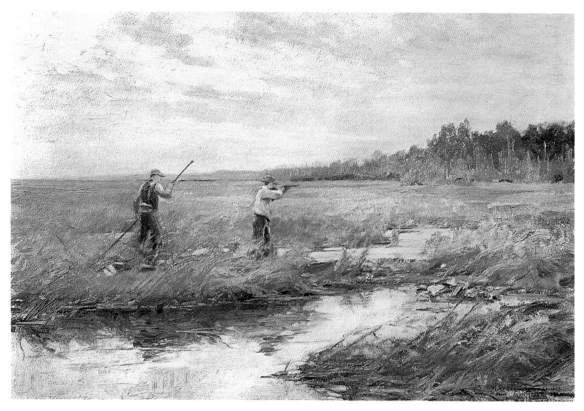

Maryland Marsh, by John Frost, 1936, lithograph.

Jack's last notable work was a series of six consecutive monthly color plates in 1935 for *The Sportsman* magazine. Made into inexpensive prints, they consisted of the fly-fishing picture, *On the Brodhead*; a rail-hunting scene, *Maryland Marsh*; *A Frosty Morning*; another duck scene, *The Limit Before Dark*; and a fine fox-hunting picture, *Autumn Morning*.

A. B. Frost's last published drawings, illustrating *A Bow to Progress*, by Thomas Boyd, were in the October 1927 edition of *Scribner's* magazine. In his last letter to his lifelong friend, Augustus S. Daggy, dated May 13, 1928, just five weeks before he died, Frost wrote:

Dear Gus:
 Thank you for your interesting letter. I couldn't answer it at once for my eyes were in bad shape.—

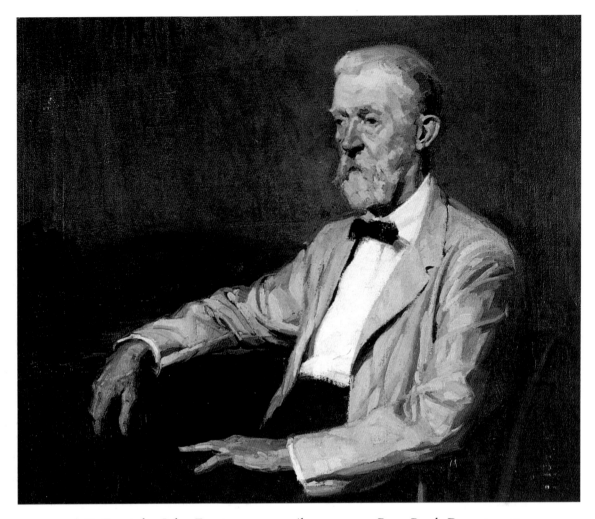

A.B. Frost, by John Frost, c. 1920, oil on canvas. Rare Book Department,
Free Library of Philadelphia.

Mrs. Frost is pretty well most of the time but she has had bad attacks of heart
trouble which alarms us, she keeps up wonderfully and is fairly well most of the time.
I am very seedy, I sleep very badly, lie awake half of the night and feel very tired and
seedy all the next day.—

I must stop. I hope you can read what I've written, it is a great effort for me to
write.

Love to the family,
Affectionately,
A. B. F.

A. B. Frost died in his sleep on June 22, 1928, in his 77th year, and is buried in Laurel Hill Cemetery, in Philadelphia. Editors of many of the prominent newspapers from coast to coast wrote eloquent eulogies on the great artist, illustrator and humorist. In his honor, many editors republished parts of *Stuff & Nonsense*, *The Bull Calf*, and *Carlo*. Typical is the editorial in the *New York Evening Post*, June 26, 1928:

A. B. FROST

It is commonplace to say that realization of the death of a friend is difficult. Yet this is the manner in which the death of A. B. Frost the illustrator, must affect the American public which he served so long, so finely and so gayly.

To Frost came not one but two or even three of the greatest immortalities to which an illustrator can aspire. His pencil gave the visual form to characters imagined by other men yet destined probably to live as long as America itself. Frost illustrated the works of Mark Twain and of Joel Chandler Harris. He created the physical semblance of Tom Sawyer, Huck Finn and Uncle Remus. He made them and all their friends as they appear today before our mind's eye. Without Frost we could not put these beloved friends into theatricals, we could not know them if we met them on the street.

Sir John Tenniel gave bodily form to Lewis Carroll's "Alice in Wonderland." Frederic Dorr Steele, we suppose created the appearance of that lesser but possibly immortal character, Sherlock Holmes. Other artists have had similar bits of brilliant fortune. But A. B. Frost, the dean of our illustrators, had even greater luck. Down through the ages, when he and we are dead and gone, his genius will twinkle on in Huck and Tom and Ole Br'er Rabbit. What price monuments of stone?

The Dorrance Sale

Not since the long-forgotten Lanier sale at the American Art Association Anderson Galleries in 1937 had an important body of A. B. Frost original works reached the auction marketplace. At that time, twenty-one lots of Frost paintings, watercolors and drawings were offered, consisting mostly of sporting subjects. Included were the two portraits of Frost ascribed to Thomas Eakins, discussed in Chapter Three. In addition to these portraits, the most important item in the sale was the preliminary but well-defined watercolor sketch for *Ordered Off*. It realized a price of $460, some 50 percent higher than the $300 paid in the same sale for the genuine portrait sketch of Frost by Eakins.

In the Burlington Trust sale conducted at Parke-Bernet Galleries in 1963, two important A. B. Frost works were offered. One was a large grisaille wash drawing depicting duck hunting. The next lot was the highly important grisaille wash drawing, the original *October Woodcock Shooting*, now in the Bucknell University art collection. It brought $2,300, a respectable price at that time. For obvious reasons it is always misleading to quote prices realized so many years ago. Still, A. B. Frost had not yet been adequately tested in the marketplace.

When the catalog of the sale of the John T. Dorrance, Jr. collection was published in the early fall of 1989, it was immediately apparent that the collection soon to be disbursed in a series of four consecutive sales, beginning on October 19, would be one of landmark importance.

The late John T. Dorrance, Jr. had been the Chairman of the Campbell Soup

Company and Chairman of the Board of Trustees of The Philadelphia Museum of Art. His collection included important old master, impressionist and modern paintings, nineteenth century European and American paintings, European ceramics and Chinese export porcelain. Sotheby's spokesman, John Marion, described it as "certainly the most valuable collection of art ever to come to auction."

Included in the Dorrance collection were thirteen of the finest A. B. Frost sporting works ever to come to the market. This was an event and opportunity which would probably never present itself again. For the first time, four of the original twelve watercolors from *The Shooting Pictures* portfolio would be sold, as well as some of the most beloved and famous of all Frost's work, including *Ordered Off*, *Gun Shy* and *The Conciliator*. Collectors had always known that the original works from which the famous prints were made must be somewhere. To come upon them "face to face" for the first time was an exhilarating experience.

The catalog listed the following works by Frost in this order:

TITLE	SOTHEBY'S ESTIMATE
Gun Shy	$18,000–22,000
Quail Shooting	$12,000–18,000
Ordered Off	$18,000–22,000
Fly Fishing	$15,000–20,000
Duck Shooting from a Blind	$18,000–22,000
On the Point	$15,000–20,000
English Snipe Shooting	$18,000–20,000
The Conciliator	$15,000–20,000
Duck Shooting	$15,000–20,000
First Release of Pheasant	$15,000–20,000
Quail—A Dead Stand	$15,000–20,000
Fall Woodcock Shooting	$15,000–20,000
Hunter Preceded by a Setter	$15,000–20,000

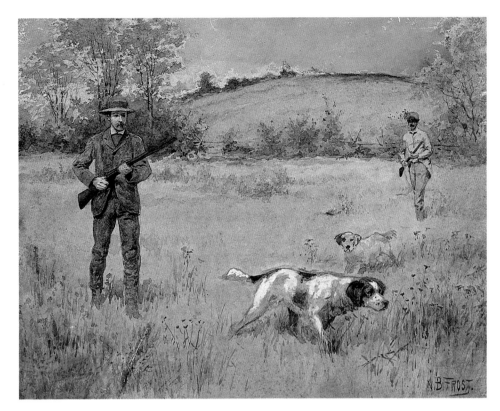

Quail Shooting, 1882, watercolor. Private Collection.

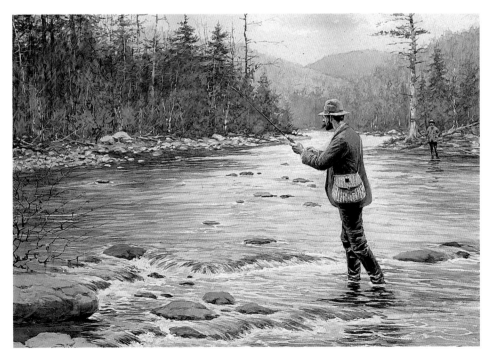

Fly Fishing, c. 1895, watercolor. Private Collection.

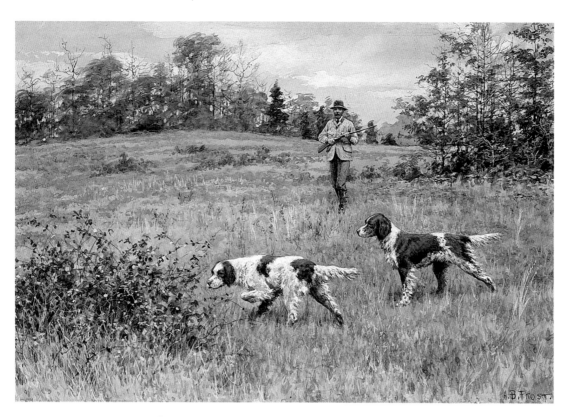

On the Point, 1895, watercolor. Private Collection.

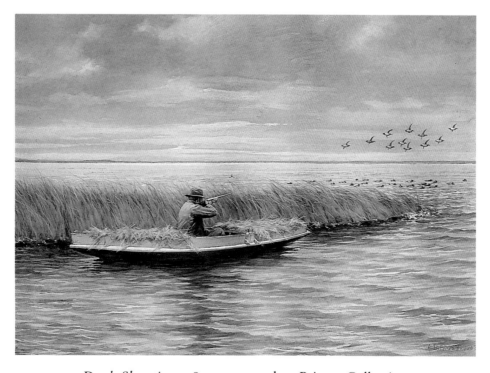

Duck Shooting, 1895, watercolor. Private Collection.

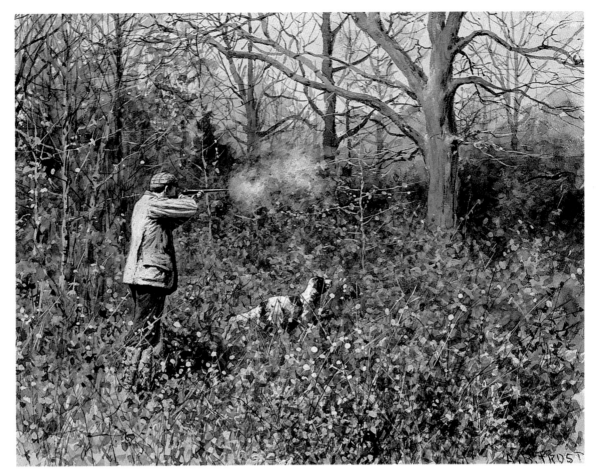

First Release of Pheasant, c. 1895, watercolor. Private Collection.

The bidding was brisk and spirited, with *Gun Shy,* the first of the thirteen consecutive Frost works to come on the block. As the bids easily exceeded Sotheby's highest estimate, the tension and excitement mounted until auctioneer John Marion finally knocked it down for a staggering $52,500. The next lot, the small somewhat crude but early *Quail Shooting of* 1881, was the only work not to reach its estimate, despite its interesting history as the earliest work by Frost from which a lithograph was published, and a never-before-seen paper label pasted on the back, on which was printed: "Property of A. B. Frost, 1330 Chestnut St., Philadelphia".

Next on the block came *Ordered Off,* and it soon became evident that history was

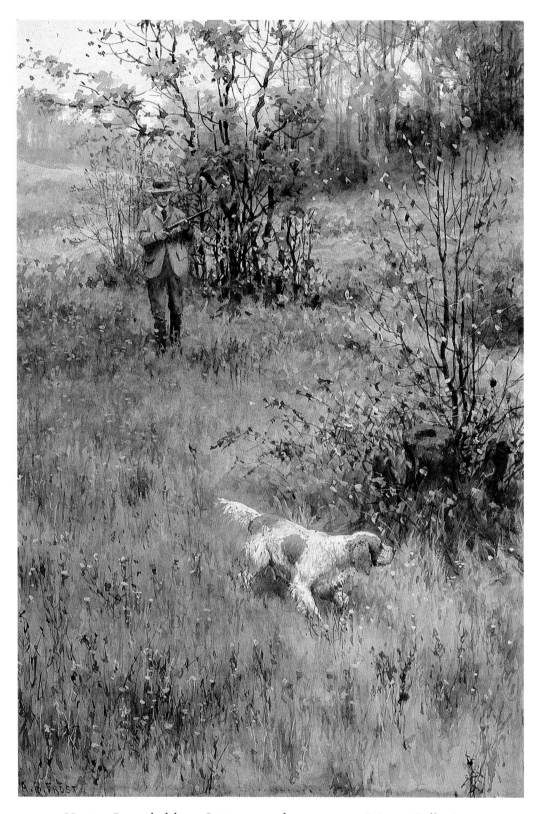

Hunter Preceded by a Setter, gouache on paper. Private Collection.

being made as the work sold for $55,000 (it should be noted that "hammer" prices are being recorded here, and that all such prices are subject to a buyer's fee of an additional 10 percent). As the sale progressed, mounting tension filled the salesroom as disappointed underbidders began to reassess their own bidding strategies. The following prices were realized:

Fly Fishing	$26,000
Duck Shooting from a Blind	$40,000
On the Point	$35,000
English Snipe Shooting	$30,000
The Conciliator	$32,500
Quail—A Dead Stand	$70,000
Fall Woodcock Shooting	$77,500
Hunter Preceded by a Setter	$18,000

In a little more than ten minutes it was over; the twelve Frosts had sold for an aggregate total of $551,457, including the 10 percent buyer's fee.

With the sale still in progress, some individuals and small groups of buzzing bidders with paddles still in hand got up and left the salesroom after the last Frost picture had been sold.

Post-sale reaction from dealers and collectors alike was ecstatic. All agreed that they had expected it to happen. One dealer declared that he had received calls from collectors across the country asking him to execute their bids. Another said that he could only do the best he could with his resources, but he wanted just one for his collection.

It was indeed a landmark sale. With competition from sporting artists such as Rosseau, Osthaus and Pleissner, and in the company of Renoir and Monet, A. B. Frost emerged as the star of *this day*. At long last he had been tested in the marketplace.

APPENDIX

Books Illustrated by
A. B. Frost

These books and publications are either fully or partially illustrated by Frost, including covers, frontispieces, title pages, color and black and white plates, engravings and text line drawings.

Philadelphia Sketch Club Portfolio, by club members. Philadelphia: January through September 1873.

Out Of The Hurly Burly, by Max Adeler. Philadelphia and New York: To-Day Publishing Co. 1874; and St. Louis: George Maclean and Co., 1874.

Around The Tea Table, by T. De Witt Talmadge. Philadelphia: Cowperthwait & Company, 1874.

Elbow Room, by Max Adeler. Philadelphia: J. M. Stoddart & Co., 1876.

One Hundred Years A Republic: Our Show, by Daisy Shortcut and Arry O'Pagus. Philadelphia: Claxton, Remsen, and Haffelfinger, 1876.

Samuel J. Tilden Unmasked! by Benjamin E. Buckman. New York: Benjamin E. Buckman, 1876.

Almost A Man, by S. Annie Frost. New York: American Tract Society, 1877.

Pictures From Italy, Sketches By Boz, And American Notes, by Charles Dickens. New York: Harper & Brothers, 1877.

American Notes And Pictures From Italy, by Charles Dickens. London: Chapman and Hall, 1877.

The Ghost Of Greystone Grange, by A. A. Beckett. London: Bradbury, Agney & Co., 1878.

Random Shots, by Max Adeler. Philadelphia: J. M. Stoddart & Co., 1879.

Success With Small Fruits, by Edward P. Roe. New York: Dodd, Mead & Company, 1880.

The Moral Pirates or *The Cruise Of The White-Wing*, by W. L. Alden, New York: Harper & Brothers, 1880.

The Young Nimrods In America, by Thomas W. Knox. New York: Harper & Brothers, 1881.

The Practical Works Of Henry Wadsworth Longfellow, 2 vols., Boston: Houghton, Mifflin & Co.; and Cambridge: The Riverside Press, 1881.

The Fortunate Island, by Max Adeler. Boston: Lee & Shepard; and New York: Charles T. Dillingham, 1882.

The Chronicle Of The Drum, by William Makepeace Thackeray. New York: Charles Scribner's Sons, 1882.

New England Bygones, by E. H. Arr. Philadelphia: J. B. Lippincott & Co., 1883.

The Lady Of The Lake, by Sir Walter Scott. Boston: James R. Osgood & Co., 1883.

Rhyme? And Reason? by Lewis Carroll. London: Macmillan & Co., 1883.

Hot Plowshares, by Albion W. Tourgee. New York: Fords, Howard and Hulbert, 1883.

Dialect Tales, by Sherwood Bonner. New York: Harper & Brothers, 1883.

Old Mark Langston, Richard M. Johnston. New York: Harper & Brothers, 1883.

Judith: A Chronicle Of Old Virginia, by Marion Harland. Philadelphia: Our Continent Publishing Co.; and New York: Fords, Howard, & Hulbert, 1883.

Stuff & Nonsense, by A. B. Frost, with jingles by Charles Frost. New York: Charles Scribner's Sons, 1884. London: Jack Nimmo, 1884.

A History Of The United States Of America, by Horace E. Scudder. Philadelphia: J. H. Butler; and Boston: W. Ware and Co., c. 1884.

The Adventures Of Jimmy Brown, by Jimmy Brown, and edited by W. L. Alden. New York: Harper & Brothers, 1885.

An Elegy Written In A Country Churchyard, by Thomas Gray. Philadelphia: J. B. Lippincott & Co., 1885.

City Ballads, by Will Carleton. New York: Harper & Brothers, 1886.

Hunting Trips Of A Ranchman, by Theodore Roosevelt. New York: G. P. Putnam & Sons, 1885.

A Tangled Tale, by Lewis Carroll. London: MacMillan & Co., 1885.

Rudder Grange, by Frank R. Stockton. New York: Charles Scribner's Sons, 1885; and London: Cassell, 1885.

A Book Of The Tile Club. Boston and New York: Houghton Mifflin & Co., 1886.

Seven Ages Of Man, from Shakespeare's *As You Like It*. Philadelphia: J. B. Lippincott & Co., 1885.

The Story Of A New York House, by H. C. Brunner. New York: Charles Scribner's Sons, 1887.

Free Joe and Other Georgian Sketches, by Joel Chandler Harris. New York: P. F. Collier & Sons, 1887.

Old Homestead Poems, by Wallace Bruce. New York: Harper & Brothers, 1888.

Mr. Absalom Billingslea And Other Georgia Folk, by Richard M. Johnston. New York: Harper & Brothers, 1888.

Virginia Of Virginia, by Amelie Rives. New York: Harper & Brothers, 1888.

Said In Fun, by Philip H. Welch. New York: Charles Scribner's Sons, 1889.

Ogeechee Cross-Firings, by Richard Malcolm Johnson. New York: Harper & Brothers, 1889.

Expiation, by Octave Thanet. New York: Charles Scribner's Sons, 1890.

City Boys In The Woods or *A Trapping Venture In Maine*, by Henry P. Wells. New York: Harper & Brothers, 1890.

Seven Dreamers, by Annie Trumbull Slosson. New York: Harper & Brothers, 1890.

The Squirrel Inn, by Frank Stockton. New York: The Century Co., 1891.

Farming, by Richard Kendall Munkittrick. New York: Harper & Brothers, 1891.

Gallegher And Other Stories, by Richard Harding Davis. New York: Charles Scribner's Sons, 1891.

The Primes and Their Neighbors, by Richard M. Johnston. New York: D. Appleton and Company, 1891.

The Bull Calf And Other Tales, by A. B. Frost. New York: Charles Scribner's Sons, 1892.

Uncle Remus And His Friends, by Joel Chandler Harris. Boston: Houghton Mifflin and Company, 1892.

The Great Streets Of The World, by Richard Harding Davis and others. New York: Charles Scribner's Sons, 1892; and London: Osgood, McIlvaine, 1892.

American Illustrators, by F. Hopkinson Smith. New York: Charles Scribner's Sons, 1892.

The Wilderness Hunter, by Theodore Roosevelt. New York: G. P. Putnam's Sons, c. 1893.

Stories Of A Western Town, by Octave Thanet. New York: Charles Scribner's Sons, 1893.

A Golden Wedding, by Ruth McEnery Stuart. New York: Harper & Brothers, 1893.

Pastime Stories, by Thomas Nelson Page. New York: Harper & Brothers, 1894.

The Water Ghost And Others, by John Kendrick Bangs. New York: Harper & Brothers, 1894.

Pomona's Travels, by Frank R. Stockton. New York: Charles Scribner's Sons, 1894.

The Story Of A Bad Boy, by Thomas Bailey Aldrich. Boston: Houghton Mifflin and Company, 1895.

Uncle Remus, His Songs And His Sayings, by Joel Chandler Harris. New York: D. Appleton and Company, 1895.

The Phantoms Of The Foot-Bridge And Other Stories, by Charles Edbert Craddock. New York: Harper & Brothers, 1895.

Rhymes Of Our Planet, by Will Carleton. New York: Harper & Brothers, 1895.

Shooting Pictures, by A. B. Frost, with text by Charles D. Lanier. New York: Charles Scribner's Sons, 1895-96.

Jersey Street And Jersey Lane, by H. C. Bunner. New York: Charles Scribner's Sons, 1896.

Tom Sawyer Abroad, Tom Sawyer Detective, And Other Stories, by Mark Twain. New York: Harper & Brothers, 1896.

That First Affair, by John Ames Mitchell. New York: Charles Scribner's Sons, 1896.

Field Flowers, by Eugene Field. Chicago: A. E. Swift and Co., c. 1896.

In Old Virginia, by Thomas Nelson Page. New York: Charles Scribner's Sons, 1896.

Tales Of Fantasy And Fact, by Brander Matthews. New York: Harper & Brothers, 1896.

Hunting, by Archibald Rogers, Birge Harrison and others. New York: Charles Scribner's Sons, 1896.

The American Railway, various authors. New York: Charles Scribner's Sons, 1897.

The Missionary Sheriff, by Octave Thanet. New York: Harper & Brothers, 1897.

Paste Jewels, by John Kendrick Bangs. New York: Harper & Brothers, 1897.

Jimty And Others, by Margaret Sutton Briscoe. New York and London: Harper & Brothers, 1897.

Solomon Crow's Christmas Pockets And Other Tales, by Ruth McEnery Stuart. New York: Harper & Brothers, 1897.

Athletic Sports, various authors. New York: Charles Scribner's Sons, 1897.

Following The Equator, A Journey Around The World, by Mark Twain. Hartford: The American Publishing Company, 1897. Also published as *More Tramps Abroad*. London: Chatto & Windus, 1897.

Moriah's Mourning, by Ruth McEnery Stuart. New York: Harper & Brothers, 1898.

Pastime Stories, by Thomas Nelson Page. New York: Charles Scribner's Sons, 1898.

Ghosts I Have Met, by John Kendrick Bangs. New York: Harper & Brothers, 1898.

The Golfer's Alphabet, by A. B. Frost, with rhymes by W. G. Van T. Sutphen. New York and London: Harper & Brothers, 1898.

The Heart Of Toil, by Octave Thanet. New York: Charles Scribner's Sons, 1898.

Pictures From Scribner's, a portfolio of plates selected from Scribner's magazine. New York: Charles Scribner's Sons, 1898.

Fur And Feather Tales, by Hamblen Sears. New York and London: Harper & Brothers, 1899.

The Easternmost Ridge Of The Continent, edited by George Munro Grant, D.D. Chicago: Alexander Belford & Co., 1899.

The Other Fellow, by F. Hopkinson Smith. Boston and New York: Houghton, Mifflin and Company; and Cambridge: The Riverside Press 1899.

The Chronicles Of Aunt Minervy Ann, by Joel Chandler Harris. New York: Charles Scribner's Sons, 1899.

Mr. Milo Bush And Other Worthies, by Hayden Carruth. New York: Harper & Brothers, 1899.

The Associate Hermits, by Frank R. Stockton. New York: Charles Scribner's Sons, 1899.

Sports And Games In The Open, by A. B. Frost, with introduction by Frank R. Stockton. New York and London: Harper & Brothers, 1899.

Devil Tales, by Virginia Frazer Boyle. New York and London: Harper & Brothers, 1900.

The Jimmyjohn Boss, And Other Stories, by Owen Wister. New York: Harper & Brothers, 1900.

First Across The Continent, by Noah Brooks. New York: Charles Scribner's Sons, 1901.

The Bears Of Blue River, by Charles Major. New York: Doubleday and McClure Co., 1901.

Understudies, by Mary E. Wilkins. New York and London: Harper & Brothers, 1901.

Salmon And Trout, by Dean Sage and others. New York and London: MacMillan & Company, 1902.

Upland Game Birds, by Edwyn Sandys and T. S. Van Dyke. New York and London: MacMillan & Company, 1902.

The Waterfowl Family, by L. C. Sanford, L. B. Bishop and T. S. Van Dyke. New York and London: MacMillan & Company, 1903.

Provincial Types In American Fiction, by Horace Spencer Fiske. New York, Chatauqua, Springfield and Chicago: The Chatauqua Press, 1903.

Tioba, by Arthur Colton. New York: Henry Holt and Company, 1903.

A Book Of Drawings, by A. B. Frost, with introduction by Joel Chandler Harris and verses by Wallace Irwin. New York: Fox Duffield & Company; and P. F. Collier & Son, 1904.

Bred In The Bone, by Thomas Nelson Page. New York: Charles Scribner's Sons, 1904.

The Tar-Baby, And Other Rhymes Of Uncle Remus, by Joel Chandler Harris. New York: D. Appleton & Company, 1904.

The Soldier Of The Valley, by Nelson Lloyd. New York: Charles Scribner's Sons, 1904.

The Second Wooing Of Salina Sue, by Ruth McEnery Stuart. New York: Harper & Brothers, 1905.

Told By Uncle Remus: New Stories Of The Old Plantation, by Joel Chandler Harris. New York: McClure Phillips & Co., 1905.

Back Home, by Eugene Wood. New York: McClure Phillips & Co., 1905.

John Henry Smith, by Frederick Upham Adams. New York: Doubleday, Page & Co., 1905.

Red Saunders' Pets And Other Critters, by Henry Wallace Philips. New York: McClure Phillips & Co., 1906.

Six Stars, by Nelson Lloyd. New York: Charles Scribner's Sons, 1906.

Bob And The Guides, by Mary Raymond Shipman Andrews. New York: Charles Scribner's Sons, 1906.

The Pets, by Henry Wallace Phillips. New York: McClure Phillips & Co., 1906.

Lyrics From Cotton Land, by John Charles McNeill. Charlotte, N.C.: Stone & Barringer Co., 1907.

The Pickwick Papers, by Charles Dickens. London: A. J. Slatter, 1908.

Thirty Favorite Paintings By Leading American Artists, New York: P. F. Collier & Son, 1908.

Little Rivers, by Henry Van Dyke. New York: Charles Scribner's Sons, 1908.

Aunt Amity's Silver Wedding, by Ruth McEnery Stuart. New York: The Century Co., 1909.

Carlo, by A. B. Frost. Garden City: Doubleday, Page & Co., 1913.

American Art By American Artists: One Hundred Masterpieces. New York: P. F. Collier & Son, 1914.

Uncle Remus Returns, by Joel Chandler Harris. Boston: Houghton Mifflin Company, 1918.

Wing Shooting And Angling, by Eugene V. Connett, III. New York: Charles Scribner's Sons, 1922.

The Epic of Golf, by Clinton Scollard. Boston and New York: Houghton Mifflin Company; and Cambridge: The Riverside Press, 1923.

The Spicklefisherman And Others, by Frederick White. New York: The Derrydale Press, 1928.

The Collected Verse of Lewis Carroll, London: MacMillan and Co., 1932.

The Uncle Remus Book, by Joel Chandler Harris, retold by M. B. Huber. New York: Appleton-Century, c. 1935.

Unless otherwise noted, all art works are by A.B. Frost.

Photographic credits: p. 19: Sotheby's, Inc., New York; p. 26: *Seventy Years Ago*/Clem Fiori; p. 37: *Arthur B. Frost* by Thomas Eakins/Eric Mitchell; p. 107: *The Conciliator*/Sotheby's, Inc., New York and *Quail Shooting*/Grand Central Art Galleries, Inc., New York; pp. 150–153: Sotheby's, Inc., New York.

Index